THREE NEW YORK DADAS AND THE BLIND MAN

MARCEL DUCHAMP

HENRI-PIERRE ROCHÉ

BEATRICE WOOD

3

INTRODUCTION BY DAWN ADES

New York Dadas *The Blind Man*

ATLAS PRESS, LONDON

Published by Atlas Press,
27 Old Gloucester St., London WC1N 3XX
©2013, Atlas Press
Translation ©2013, Chris Allen
Works of Marcel Duchamp published with permission of
Jacqueline Matisse Monnier (Association Marcel Duchamp);
of Henri-Pierre Roché by Jean-Claude Roché;
of Beatrice Wood by the Beatrice Wood Center for the Arts,
Happy Valley Foundation, Ojai, California.
All rights reserved.
Printed by CPI Group (UK) Ltd, Croydon, CR0 4YY
A CIP record for this book is available from
The British Library.
ISBN: 1 900565 43 9
ISBN-13: 978-1-900565-43-1

We would like to express our gratitude
for the generous financial assistance of:
THE ELEPHANT TRUST

CONTENTS

Cast, chronology and commentaries have been compiled jointly by
Dawn Ades and Alastair Brotchie

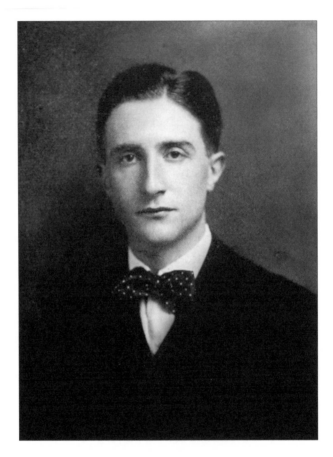

Marcel Duchamp in September 1915,
shortly after first arriving in New York.
Photograph by Gotthelf Pach.

INTRODUCTION

Victor, Henri-Pierre Roché's *roman à clef* about Marcel Duchamp and the Arensberg circle in New York during the First World War, was unfinished at his death in 1959 and unpublished in his lifetime. While Roché is best known for his 1953 novel, *Jules et Jim*, an astonishing number of his writings remain unpublished, partly because he put more energy into his life, loves and collecting than into a literary career. Sent to New York on a mission by the French government in 1916, he became a close friend of Duchamp, then the most notorious artist in the USA, and "with Napoleon and Sarah Bernhardt, [...] the most famous French person in America" (p.51).

Duchamp had arrived there in June 1915 in retreat from the war in Europe. Both Roché and Duchamp became intimates of the poet and collector Walter Conrad Arensberg and his wife Louise, who held open house for a small group of artists and writers and helped fund several of the little magazines that were the life-blood of the avant-garde in New York, including Allen and Louise Norton's *Rogue* (1915-16) and Alfred Kreymborg's *Others* (1915-19).[1] Roché had a close relationship with the young New York actress and artist Beatrice Wood, author of the memoir *I Shock Myself*, but just as Roché's real passion seems at the time to have been for Louise Arensberg, Wood fell for Duchamp, whom she met when they were both visiting the composer Edgar Varèse, hospitalised with a broken leg. She described how Roché "teased me about being in love with Marcel. Instead of being jealous, he was delighted when I told him I dreamt of Marcel. For Roché loved Marcel too, as I think everyone who knew him did. Marcel was a beautiful, abstract, yet loving human being." (p.160) Duchamp was earning a living teaching French, which was also a handy way for him to learn English; Wood was already fluent in

1. See Steven Watson, *Strange Bedfellows: The First American Avant-garde*, Abbeville, 1991; Francis M. Naumann, *New York Dada 1915-23*, Abrams, 1994.

French, but he taught her French slang that horrified her bourgeois acquaintances and the more correct of her French artistic friends, such as the Cubist painter Albert Gleizes. Discovering her difficult and repressive home life, Duchamp invited her to come and paint in his studio, a characteristic act of generosity.

The collaboration between Roché, Wood and Duchamp on *The Blind Man* in 1917, variously reported in the novel and the memoir published here, marked not only a lively addition to the plethora of little magazines in New York but registered a gesture that was to have a far-reaching effect on the art of the 20th century. Breton was to describe Duchamp, at the high point of Dada in Paris in 1922, as reaching "the *critical point* of ideas faster than anyone else."[2] With *Fountain* and the discussion it generated in *The Blind Man* Duchamp did exactly that, pinpointing the intersection of conflicting ideas about art, sex and morals in the modern world. This apparently dumb piece of plumbing hit the nerves of the budding contemporary art scene in New York: it was an act of sabotage *vis à vis* the newly founded Society of Independent Artists; a variation of the readymades that puzzled even those who thought they understood them, like Duchamp's patron Katherine Dreier; a response to Robert Coady's macho aesthetics and primitivist patriotism in *The Soil*; and a test of the very notion of originality, if not art itself.

The word "Dada" hadn't yet spread to New York, though the network of the international avant-garde that passed, via correspondence and the little magazines, through Apollinaire in Paris, Tzara in Zurich, de Zayas in New York and Picabia wherever he happened to be, was functioning despite the war.[3] Duchamp and the Arensbergs at the time were not fully aware of the nascent Dada in Zurich;[4] as Duchamp wrote later to Anthony Hill, "We had our iconoclastic fun without

2. André Breton, "Marcel Duchamp", *Littérature*, no. 5, Paris, October 1922.

3. Picabia started his peripatetic magazine *391* in Barcelona in January 1917, produced three issues in New York (June-August 1917), one in Zurich (February 1919) and issues 9-19 in Paris (1919-24). By November 1916, de Zayas, who had published the visually stunning *291*, (12 issues, 1915), had been sent a publication from Tzara in Switzerland, and sent some examples of *291* in return. De Zayas saw this Zurich review, still quite sober, as appealing to people interested in the modern art movement. The letter from de Zayas to Tzara (Michel Sanouillet, *Dada à Paris*, Pauvert, p.572) mentioned the latter's "interesting publication *Dada*". The letter is dated November 1916, so it must have been *Cabaret Voltaire* (May 1916), which featured an announcement for the future review *Dada*, whose first issue appeared in July 1917.

knowing that there was a word for it in Zurich — and certainly Varèse's music was the right song to it."[5] The *Fountain* scandal of 1917 was one of the first manifestations of the fault-lines that were emerging within the avant-gardes, between those who continued to pursue the "evolution of modern ideas", as de Zayas put it, and Dada's iconoclasts, between the accredited modernists and the subversive few who asked awkward questions about the value of art in the modern era, and whether it might not be quite where people thought it was.

The Blind Man was one of several spirited and unconventional little magazines published in New York during the 1910s. These included *291*, *The Glebe*, *Rogue*, *The Soil*, *Others*, *391*, *Rongwrong*, *The Ridgefield Gazook* and *TNT*. *Camera Work* and *The Little Review* were hardly little magazines but their contents crossed over occasionally.[6] Some were homegrown, some produced by European refugees or visitors, some by a mixture of both. Most were ephemeral, and have been seen as marginal to histories of modern art and literature, although it is often in them that the stirrings of new ideas, experimental attitudes to word and image and unusual collaborations between poets and artists become apparent. The most visually inventive of the little magazines were *291* and *391*. They were also at the heart of bohemian life in Greenwich Village, where the first fund-raising costume ball, based on the Left Bank tradition of the Quatre-Arts balls in Paris, was held in 1914 for the socialist magazine *The Masses*. In September 1916 Duchamp was a judge for the costumes at the Ball to celebrate the second series of *Rogue* and on 25 May 1917 the Blindman's Ball was held. Its programme of performances by the Japanese dancer Michio Itow was published in the third of the little magazines produced by Duchamp and co., *Rongwrong*.

The first issue of *The Blind Man* was published in order to cheerfully trumpet the opening of the first exhibition of the newly founded Society of Independent Artists; the second issue in May 1917 prominently denounced it.

4. Duchamp recalled Tzara sending him or Picabia his *La première aventure céleste de Mr Antipyrine* at the end of 1916 or in 1917 (Duchamp, *Entretiens*, Pierre Belfond, p.99).

5. Letter from Duchamp to Hill, 6 May 1951 (unpublished, private collection).

6. *Camera Work*, ed. Alfred Stieglitz; *The Little Review*, ed. Margaret Anderson and Jane Heap.

The first issue was entirely written by Roché and Wood, apart from one contribution from Mina Loy, recently arrived from Italy where she had been close to Marinetti and the Futurists. Her short text probes the awkward relationship between the Artist and the Public, contaminated by Education, which is "the putting of spectacles on wholesome eyes." Beatrice Wood wrote about the preparations for the Independents exhibition, which had opened the day before the magazine was published. Given her accounts of being a picture-hanger and of having a dream involving one of the paintings she herself submitted to the exhibition, it's clear that the magazine was hastily put together at the last minute. One of the two paintings she sent in was a rather abstract nude of a woman in a bath with a piece of soap "drawn at the 'tactical' position", as she writes. Duchamp had suggested she use a real bar of soap instead, scallop-shaped, and approved the title *Un peu d'eau dans du savon* (A Little Water in Soap, p.169). In her dream, "I was a piece of soap with nails in my back stuck on a canvas. A big flood came and swamped all the first floor, and the canvases began whirling on the ground... blue arms and green legs floated past, and I said to myself: those are the art-critics." (p.129)

In his texts Roché welcomed the imminent Independents exhibition, described its 1884 predecessor in Paris, presented *The Blind Man* as the "link between the pictures and the public", invited contributions and promised to publish reproductions of the most talked-of works. The Indeps, he assured readers, would rectify the problem of New York being provincial as far as art was concerned, and that contemporary art was not recognised in the USA. "Russia needed a political revolution. America needs an artistic one." (p.128) Roché names *291* and *The Soil* as harbingers of this revolution.

The Society of Independent Artists, Inc. was modelled directly on the French Salon des Artistes Indépendants and adopted the same fundamental principles: "No Jury — No Prizes". A third measure, "to ensure equality of opportunity for exhibitors", as the official announcement of the founding of the Society put it in December 1916, was adopted by the directors, which was to hang all works in alphabetical order. This was not therefore, as is often stated, a last-minute decision by Duchamp in April 1917, as head of the hanging committee, when faced with 2,400 paintings and 350 sculptures by 414 women and 821 men (although he may have made the original suggestion). There were no requirements for admission to the Society, and anyone could exhibit on payment of an "initiation" fee of $1, and

$5 annual dues. The directors included George Bellows, John Covert, Katherine Dreier, Duchamp, Rockwell Kent, John Marin, Man Ray, Morton Schamberg and Joseph Stella. On 6 April, Duchamp drew the letter R from a hat to determine the order of the hang.[7] The exhibition opened on 9 April at the Grand Central Palace on West 35th Street.

What exactly happened to *Fountain* on the eve of the exhibition is unclear. According to newspaper accounts a group of directors was hastily gathered and the issue hotly debated, with "Mr Mutt's defenders voted down by a small margin". The sculpture then, according to Katherine Dreier, was "surreptitiously stolen", probably hidden by the winners of the debate to prevent its surreptitious inclusion. Duchamp and Arensberg resigned immediately as directors of the Society. By 13 April, Duchamp and Wood had recovered *Fountain* and taken it off to be photographed by Stieglitz for the second issue of *The Blind Man*, then in preparation.[8]

Duchamp's resignation was widely reported in the newspapers in conjunction with references to Mr Mutt of Philadelphia. Dreier, who was clearly not in on the plot, wrote to Duchamp begging him to reconsider his resignation, explaining apologetically that she had voted against Mutt's object because she couldn't see anything original in this "Readymade". On 26 April she wrote to William Glackens, the President of the Society, warmly congratulating him on resolving the ongoing crisis by inviting both Duchamp and Richard Mutt to lecture at the gallery, the latter to bring the "discarded object with him" and explain his "theory of art". Although she recognised in this letter that the use of the name Mutt, because of the popular *Mutt and Jeff* cartoon, raised suspicions that this was a joke, she still took the whole affair very seriously. Appearing as Gertrude in *Victor*, and clearly here aware of the perpetrator's identity, she is made to voice some sympathy for American prudery at one of the evening salons at the apartment of Gontran and Alice (Walter and Louise Arensberg): "a country that is basically Anglo-Saxon cannot be rid of its prudishness in matters concerning the lavatory with just one swipe. Rabelais wasn't from these parts. It isn't that Victor is wrong, he is marking

7. Jennifer Gough-Cooper & Jacques Caumont, *Marcel Duchamp, Vita*, 6 April 1917, Bompiani, 1993.

8. For a detailed account of this episode and the context of the machine aesthetic discussed later, see William Camfield, *Marcel Duchamp: Fountain*, Menil, 1989.

an era, that's all." (p.59f.) Victor (Roché continues), "showing no interest, was already thinking about something else."

The situation about *Fountain* was made public (but without revealing Duchamp's involvement) in the second issue of *The Blind Man*, in May 1917, which turned against the Independents and attacked it for refusing, as the magazine put it, to exhibit "Fountain by R. Mutt". Opposite a photograph by Alfred Stieglitz of the urinal, captioned "The Exhibit refused by the Independents", was the famous unsigned text "The Richard Mutt Case", followed by Louise Norton's "Buddha of the Bathroom". "The Richard Mutt Case" was thus the first published statement about the concept of the readymade, and it has usually been assumed that the author was Marcel Duchamp. However, it was in fact written, as she says in her memoirs (p.165), by Beatrice Wood. While there is no doubt that Duchamp was behind the incident, the fact that the public interpreters of the male urinal were all women is very significant.

The ideas behind the submission of the urinal/sculpture/*Fountain* to the Independents, expressed in the two explanatory texts, were evidently familiar to those in Duchamp's immediate circle. Wood describes witnessing an encounter between the muscular painter George Bellows and Duchamp's close friend and patron Walter Arensberg, just before the opening of the exhibition, and the exchange she reports almost exactly mirrors the language of "The Richard Mutt Case" in *The Blind Man*. A furious Bellows roared that the white porcelain object was indecent, a joke, impossible to exhibit. Arensberg replied that it must be shown as the entrance fee was paid, and went on: "A lovely form has been revealed, freed from its functional purpose ... This Mr Mutt has taken an ordinary object, placed it so that its useful significance disappears, and thus has created a new approach to the subject." (p.164) Or, as the text of "The Richard Mutt Case" put it: "He took an ordinary article of life, placed it so that its useful significance disappeared under the new title and point of view — created a new thought for that object." (*The Blind Man* 2, p.135 below) Even if Wood drew on this published text in her memoirs, it is reasonable to assume that both Walter Arensberg and Wood had been privy to Duchamp's ideas in the run up to the scandal, that the language was familiar to the small group and that the plot was more of a collective than is admitted.

The tangled issues of moral impropriety in both art and life in the context of the

modernism Duchamp was prodding at with *Fountain*, and which were so strongly presented in the little magazines like *Rogue*, *The Soil* and *Others*, were neatly skewered in the second issue of *The Blind Man*, in texts by close female friends of Duchamp. The whole affair was a joint effort, like the magazines themselves.

Wood's "The Richard Mutt Case" and Norton's "Buddha of the Bathroom" present elegantly complementary defences of *Fountain*. Wood answers the criticisms that it was: 1. immoral, vulgar, 2. plagiarism, by pointing out firstly that it was an everyday object on open display in plumbers' show windows, secondly that in decontextualising the article (tipping it on to its back) and giving it a title he had given it a new thought. She concludes: "The only works of art America has given are her plumbing and her bridges." Norton picks up from there, in a discursive text littered with quotations in total contrast to the manifesto-like "Richard Mutt Case", and highlights the aesthetic appeal of the object: "... to any 'innocent' eye how pleasant is its chaste simplicity of line and color! Someone said, 'Like a lovely Buddha'..." She insists that "the *Fountain* was not made by a plumber but by the force of an imagination", and concludes by suggesting that "he" is perhaps both serious and joking. Whereas Wood centres on the immediate context of modernity in America, hygiene and engineering, Norton delicately explores the sculpture in relation to the past, managing simultaneously to chastise our worship of artistic antecedents and suggest that *Fountain* has a timeless quality. "At least as a touchstone of Art how valuable it might have been! If it be true, as Gertrude Stein says, that pictures that are right stay right, consider, please, on one side of [*sic*] a work of art with excellent references from the Past, the *Fountain*, and on the other almost any one of the majority of pictures now blushing along the miles of wall in the Grand Central Palace of ART."

The importance of these two texts, the first to offer public statements about the concept of the readymade, has rather overshadowed *The Blind Man* 2 as a whole. However, the new cohort of writers, poets and artists in its pages, some already straining against sense and nearly half of whom were women, provided a great deal more than merely serving as a backdrop to *Fountain*. Most of these women artists and writers had previously been contributors to *Rogue*. In surrounding *Fountain* with female interpreters, and in the process drawing on the unusual character of the feminism in the recently defunct *Rogue*, Duchamp distanced his

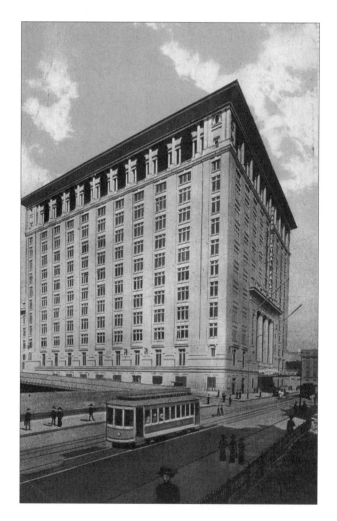

The Grand Central Palace in New York,
venue for the Independents exhibition in 1917.

factory-made object both from Picabia's mechanically inspired drawings and paintings in *291* and *391* and from Robert Coady's macho celebration of "American art" in *The Soil*.

Some of the ambiguities around *Fountain*, such as its own gender and that of its perpetrator, could be ascribed to collaboration with the ex-*Rogue* contingent, which included, as well as Norton, Clara Tice, Mina Loy and Frances Stevens. Duchamp told his sister, at the time, that *Fountain* had been submitted by a female friend:

> The Independents opened here with huge success.
> One of my female friends under a male pseudonym, Richard Mutt, sent in a
> porcelain urinal as sculpture;
> It wasn't at all indecent. no reason to refuse it. The committee decided to
> refuse to exhibit this thing. I've handed in my resignation and it'll cause
> a commotion in New York which has its uses.
> I wanted to make a special exhibition of the Independents' *refusés* — but that
> would be a pleonasm!
> And the urinal would have been *lonely* — [9]

The telephone number on the object's submission label was Louise Norton's. Thus, rather than being an early manifestation of Rrose Sélavy, Duchamp's alter-ego, he had a real female accomplice.

As "Dame Rogue", Louise Norton wrote the column "Philosophic Fashions" in *Rogue*, which set the tone for its "arch, muted or jocular" feminism.[10] Dame Rogue's priorities were not stridently feminist, but more like an early version of "the personal is political". She was concerned with the more intimate things of life such as dressing and undressing, beds, window-shopping and the bathroom, and showed "a remarkable interest in plumbing." The new woman was a free agent, smoked, made love more freely and refused to wear corsets. A "Roguery" in the first issue reads: "Forecast for 1916: shorter skirts and suffrage." Clara Tice, a regular

9. Letter to Suzanne Duchamp, 11 April 1917, *Affectionately, Marcel*, ed. Francis M. Naumann and Hector Obalk, Ludion Press, 2000, p.47.

10. Jay Bochner, "The Marriage of *Rogue* and *The Soil*", *Little Magazines and Modernism*, Ashgate, 2008, p.51; "a remarkable interest in plumbing" is from here too (p.56).

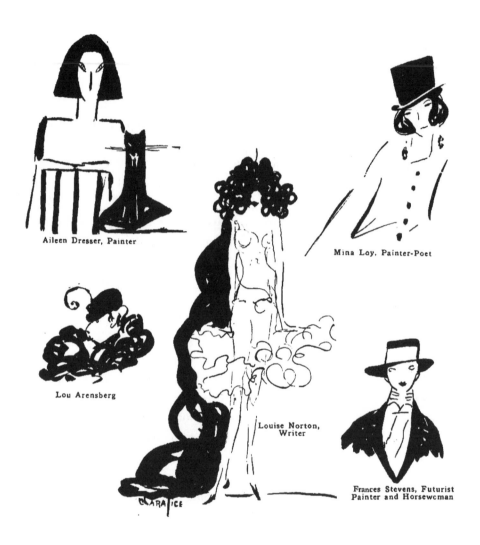

Aileen Dresser, Painter

Mina Loy, Painter-Poet

Lou Arensberg

Louise Norton,
Writer

Frances Stevens, Futurist
Painter and Horsewoman

Above: a selection from Clara Tice's drawings of "Who's Who in Manhattan", Cartoons
Magazine, *August 1917. Right: the first and last issues of* Rogue,
March 1915 and December 1916.

contributor to *Rogue* and notorious for her drawings of nudes, sketched some of these female protagonists of the New York avant-garde. Her "Who's Who in Manhattan" (opposite) included "Mina Loy, Painter-Poet" with cropped hair and a top hat, "Frances Stevens, Futurist Painter and Horsewoman", Lou Arensberg in fur and feathers and "Louise Norton, Writer" with wildly curling hair and wearing, ironically, only a corset and a short frilly skirt.

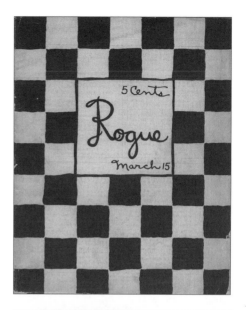

Rogue described itself variously as the "Ford" or the "cigarette" of literature, which suggests a casual levelling of culture, but it was also at the extreme end of modernist experiment with language, publishing Gertrude Stein as well as Mina Loy. Its brand of modernism was, as Jay Bochner has argued, almost entirely produced by women.[11] Duchamp himself contributed the short text "The" to *Rogue*, in which the definite article, always a shibboleth for French speakers, was omitted. His association with the *Rogue* feminists highlights his desire to explore the far from straightforward relationship between gender and modernism flaunted by the new woman. The two pieces Mina Loy contributed to the second issue of *The Blind Man* equally show a close

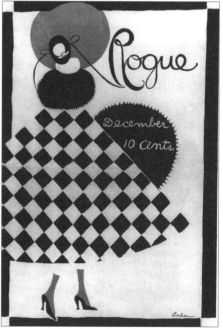

11. *Ibid.*

17

affinity with Duchamp: "Pas De Commentaires! Louis M. Eilshemius" and "O Marcel... otherwise, I Also Have Been to Louise's". The first concerns the pictures of Louis Eilshemius, an academically trained painter championed, to most people's bewilderment, by Duchamp, which lie, she wrote, "outside every academic or unacademic school, untouched by theory or 'ism', [and] survive as the unique art form that has never been exploited by a dealer, *never* been *in fashion!*" She ends: "Anyhow, Duchamp meditating the levelling of all values, witnesses the elimination of Sophistication." The second text is more experimental, apparently a brilliant portrait of an evening at (Louise) Arensberg's, compiled from fragments of conversation. The effect is not unlike the Futurists' notion of immersion in a "zone of intense life", though the life in this case seems frivolous and inconsequential. The verbal snippets may, though, have been drawn from a very different source, the nights at Louise Norton's shared by Roché and Duchamp. As Dame Rogue put it: "Beauty for the eye, satire for the mind, depravity for the senses! Of such is the new kingdom of art. Amen."[12]

Duchamp had no work in the Independents exhibition, and there were no texts by him in *The Blind Man.* Not only was *Fountain* interpreted there by women but the urinal acquired a womanly shape through its new orientation and the lighting in Stieglitz's photograph. While Louise Norton chose the Buddha as her formal analogy, Beatrice Wood always called it the Madonna, thus further feminising this most masculine of objects. Both iconic analogues serve to steer it away from the industrial aesthetic championed by Robert Coady in *The Soil.*[13]

In many ways *Fountain* and its presentation in *The Blind Man* were a deadpan but quite direct riposte to Coady, to his championing of American machinery, his aggressive nationalism and also his angry denunciations of the avant-garde, in particular his attack on Jean Crotti's *Portrait of Marcel Duchamp (Sculpture Made to Measure)* of 1915. Crotti had described this wire and plastercast sculpture as "an absolute expression of my idea of Marcel Duchamp."[14] Coady mocked this

12. Dame Rogue, *Rogue* (1915), quoted in *Strange Bedfellows, op. cit.*

13. In a nice conceit, Bochner characterises *Rogue* and *The Soil* as female and male, symbolised by the actual marriage of Mina Loy, one of the strongest voices in *Rogue*, and Arthur Cravan, who featured prominently in *The Soil.*

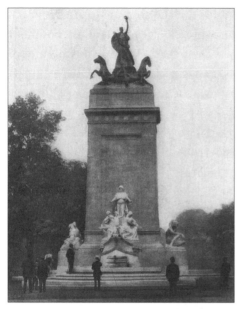

The captions to these pictures in The Soil *read, top:* Maine Monument, Chambersburg Double Frame Steam Hammer: Which is the Monument? *Right (edited here):* Cosmopsychographical Organization by R.J. Coady. "Cosmopsychographical Organization" or, the "plastic" "visualization" of my "intellectualized sensations." Wherein is "infinity struggling for birth in the womb of the soul," "surrounded by swift moving nudes." Wherein, also, "I pay no heed to mere objects" for "the path moves towards direction" where I pay "homage" to the "absence of M… D…"

"What does 2.91 mean to you when in five months' time those pictures will be worth twice what is being asked for them today?" And, besides, "we guarantee these pictures" — "in so far as honest expert opinion can guarantee anything" …

statement in *The Soil*: "Is your 'absolute expression' the absolute expression of a big artist, how does it differ from the absolute expression of a little artist, how does it differ from the absolute expression of a — plumber?" Perhaps this barb gave Duchamp the idea for *Fountain*, with the extra twist of Beatrice Wood's famous defence cited earlier "… the only works of art America has given are her plumbing and her bridges."

In his articles on American art in the first issues of *The Soil*, Coady enthusiastically enumerated what he considered as examples ("young, robust, energetic, naïve…") which indiscriminately incorporated the popular, industrial, natural and folkloric: "The Panama Canal, the Sky-scraper and Colonial Architecture… The Carpenters, the Masons, the Bricklayers, the Chimney Builders, the Iron Workers, The Cement Mixers… the Buckets and pumps…" as well as Rag-time and Cigar-store Indians. What American art was not, in Coady's view, was art as understood by the European coteries: "It is not a refined granulation nor a delicate disease — it is not an ism. It is not an illustration to a theory, it is an expression of life — a complicated life — American life." Duchamp must have been aware not only of Coady's confused version of anti-art[15] but also of the direct attack on himself (and on *291*) in the first issue of *The Soil* (December 1916), in a satirical collage, *Cosmopsychographical Organization*, whose caption included various references to Duchamp, including "where I pay 'homage' to 'the absence of M…D…'".[16]

Coady developed his argument visually on a grand masculine scale with "Which is the Monument?" (no. 2, January 1917), which contrasts the Maine Monument with the Chambersburg Double Frame Steam Hammer, and with the "Moving

14. See Menno Hubregtse, "Robert J. Coady's *The Soil* and Marcel Duchamp's *Fountain*: Taste, Nationalism, Capitalism, and New York Dada", *RACAR*, XXXIV, no. 2, 2009.

15. Dickran Tashjian in *Skyscraper Primitives* (1975) points out the contradictions in Coady's articles on "American Art" in *The Soil*, 1 & 2.

16. The caption to *Cosmopsychographical Organization* ended with an attack on Stieglitz's 291 gallery. Coady was also an art-dealer and had opened the Washington Square Gallery with Michael Brenner in spring 1914. In late 1916 he moved it to Fifth Avenue, renaming it the Coady Gallery; the advert for it in issues of *The Soil* reads: "The Art Value and the Market Value of each Work Permanently Guaranteed". Coady was particularly needled by Stieglitz's uncommercial attitude to the art in his 291 gallery.

Sculpture" series (no. 3, March 1917), which featured photographs of massive machines and locomotives.[17] (He would have been unaware of Duchamp's earlier readymade, the Cubo-Futurist "moving sculpture" *Bicycle Wheel* of 1913 and 1916.) Norton's praise for the lovely simplicity of line in the Buddha/Madonna may be genuine, but it also has a satirical note when taken in conjunction with arguments in *The Soil* for a "new kind of beauty". Hogarth's *Analysis of Beauty* is mobilised there to support the abstract aesthetic of machinery and the "splendid curves in the stream line": "Hogarth's line of beauty is rivaled by the perfect Indicator Diagram of the reciprocating engine..."

Coady was perfectly capable of celebrating Arthur Cravan, whose masculinity was hardly in doubt, and devoted most of one issue of *The Soil* to texts by him, but he seemed unaware that Cravan was allied with the forces that were questioning the Cubist and Futurist modernism he admired. He was well able to appreciate, however, that the satirical machine paintings of Picabia, and Duchamp's obscure mechanical objects such as the *Chocolate Grinder* on the cover of *The Blind Man, 2* (with its delicate Louis XV legs!), were not intended as the muscular celebrations of machinery which he was promoting.

Roché's rather limited account in *Victor* of *The Blind Man* and the fate of *Fountain* interestingly places the magazine itself at the centre of the incident. The first issue of *The Blind Man*, whose articles were "a challenge to the orthodox", was to be advertised by Patricia (Beatrice Wood) and a friend dressed up as sandwich-women walking up and down outside the entrance to the exhibition sporting provocative posters, and to be sold cheaply to visitors right beside the tills. Both ideas were put a stop to, and instead it was placed on a table in the exhibition where nobody bought it. Roché says that it was because he was "annoyed by such timidity" that Victor "demonstrated to the Independents that they were nothing of the sort by

17. Both *Rogue* and *The Soil* contain striking formal visual comparisons with *Fountain*; Bochner also mentions the similarity with a drawing of *Baptist Church Fiji Islands* reproduced in *Rogue* opposite Duchamp's "The". *Fountain* as parody of Coady's machine aesthetic was discussed by me in Ades, Cox & Hopkins, *Marcel Duchamp* (Thames and Hudson, 1999). The parallel with the outline of the steam hammer in *The Soil* is particularly striking; see also Hubregtse (*op. cit.*).

exhibiting a white porcelain urinal, placed horizontally and signed with a pseudonym, which was concealed in a special cupboard." (p.56) Although irritation at the invisibility of the first issue of *The Blind Man* is not convincing in itself as a motive for exhibiting a urinal, which Beatrice Wood explains by way of contrast as "Marcel testing the liberalism of the by-laws" of the Independents exhibition (since any artist could exhibit having paid the entrance fee), none the less, given the time lag between the events and the writing of Roché's book, his recollection of the central role of the magazine is significant. Furthermore, with Roché having been one of the editors, this does suggest that *The Blind Man* was set up, as Duchamp later suggested, to justify the *Fountain*-urinal. Roché also confuses the odd little magazine, *Rongwrong*, that followed *The Blind Man* with its predecessor, but again revealingly. "'Let us die and be born again,' Victor announced. 'Let us put together another magazine.' The second magazine, even more fanciful and brilliant and edited by Victor's female friends, was called '*Rong-Wrong*' and ran to two issues." (p.56) There appear to be no female contributors in *Rongwrong*, unlike the second issue of *The Blind Man*, so it must be the latter to which Roché is referring. Duchamp recalled *Rongwrong* coming out between the two issues of *The Blind Man*, but its odd editorial in the form of a letter to the "editor", signed Marcel Douxami [Marcel Sweetfriend], comments on "Buddha of the Bathroom" which was published in *The Blind Man* 2: "The exquisite psychologist Louise Norton, she of the big hat, who, concerning urinals, invokes in such eclectic fashion Montaigne, Nietzsche and Remy de Gourmont..." The letter otherwise complains about *391* and the "automobile spirit" of Picabia's machine paintings which are "very unpleasant for my intellect and dangerous for my reason." This appears to have been a genuine letter; if so Duchamp must have been amused by the author's name which most people would have assumed was another pseudonym.[18] Certainly fake letters of complaint do appear in *Rogue* and in *The Blind Man*: the "Letter from a Mother", for instance, in *The Blind Man* 2, begging that "we keep this exhibition sane and beautiful" and opining "People without refinement, cubists, futurists, are not artists. For Art is noble. And they are distorted", was written by Beatrice Wood. *Rongwrong* also published the chess-game between Picabia and Roché, representing respectively *391* and *The Blind Man* — a match played to decide which

18. Michel Sanouillet, *Francis Picabia et 391*, Losfeld, 1966, p.68.

of these two little magazines would continue to be published (p.49). Roché resigned the game, and *The Blind Man* ceased publication. In *Victor*, Pierre and François are surprised to see their mediocre but intensely fought game appear in print, and Victor's reason for noting it was similar to Duchamp's liking of Eilshemius: the game was "lyrical, heroic and romantic with its inadvertent copying of famous positions, its sudden mysterious panics, overflowing with imagination and even, now and again, a good move. In short it was proof that, even without any special technical knowledge, high emotions could be a part of chess too." (p.48)

Roché's diaries record an astonishing number of love affairs, liaisons and brief encounters beside which the one infidelity discovered by Beatrice in her memoir pales. Gertrude Stein's portrait of Roché is particularly apt: "This one is certainly loving, doing a good deal of loving, certainly this one has been completely excited by such a thing, certainly this one had been completely dreaming about such a thing."[19] The "free love" embraced by the new woman as part of her social liberation, and in some respects as important to gender equality as the vote, was also liberating rather than threatening for men. As Floyd Dell, managing editor of *The Masses*, wrote, "Feminism is going to make it possible for the first time for men to be free." But Roché, freely engaged as he was with the women in his and Duchamp's circle, was not really attuned to the sexual politics at stake in *Fountain* and their significance for art. For Roché, life definitely trumped art. Duchamp had already shivered the relationship between art and life with the readymades; with *Fountain* he collaborated with the New Woman in New York's bohemia to produce an object that confuses male/female boundaries, the public and the private, and the traditional relationship between beauty and utility. Before *Fountain*, the readymades were not particularly gender-responsive, but now he had chosen one that was unmistakably gendered. The urinal was posited, by Duchamp and his feminist allies, against the masculinist (Malic?) rhetoric and the plumbing taunts in Coady's *The Soil*; not only does its exclusively masculine function hardly conform to Coady's aesthetics, which preferred steam hammers, locomotives and cranes, but this function is subverted, producing a supremely ambiguous object in which the mischievous feminist modernism of *Rogue* met Dada, to explosive effect.

19. Gertrude Stein, *Geography and Plays*, Four Seas, 1922, p.141.

I

(Essai direct)

Pierre est seul dans sa chambre au sous-sol, très
carré, bien chauffée
C'est une cave qui lui sert de chambre, en largeur
avec une fenêtre de la hauteur de haut,
au plafond, par laquelle on voit les jambes des passants
mais assez bien arrangé en chambre basse,
avec quelques vieux objets impossibles, et bien
mais Un grand lit à deux.

Des pas dans la neige. On frappe. Il est minuit. Entrent en coup de
vent Victor, François et une girl brune
Ils tiennent chacun par un bras.
Ses grands yeux noirs,
sont pleins d'humour, de décisions, de bonnes
fois, et de théâtre.

Victor nous te présentons dit Victor.
 Au Brevoort elle nous
a François et moi.
veut comprendre rien à rien, parce qu'elle ne veut pas.
Elle a simplement bloqué la conversation
Et Nous avons à causer
(François et moi.

François. — Nous avons hésité entre
deux sanctions, dit François. De l'huile de
ricin, (on en vend au café) ou toi,
nous t'avons dépeint. Elle a choisi
Elle t'a préféré: Elle a besoin d'un entretien odieux
 sur ce qu'elle a fait ②

TRANSLATOR'S PREFACE

The manuscript of *Victor* runs to just over 100 pages, written in two notebooks the first of which is dated as below (10 February 1957), the second as having been started on 29 April 1957 and finished on 25 November that year (the discrepancy with the date which appears in the text, 7 September 1958, is not explained in the published edition). The manuscript shows abundant re-working, in several places with up to four different choices of words or phrases, according to its editor, together with passages or whole pages crossed out; to have represented this in its entirety would have necessitated an apparatus of notes equivalent in size to the text itself, so instead the editorial decision was taken to concentrate on the initial writing, omitting the majority of variants and struck-through parts except where these were deemed to offer something of sufficient interest to include. This edited version was published in 1977, as the fourth volume in the Pompidou's Duchamp catalogue, with the manuscript introduction also indicating that the sequence of the chapters corresponds to that given by Roché in his notes.

Roché kept a diary for nearly 60 years, and in the 330 or so notebooks which thus accumulated, he recorded his numerous personal encounters and not least his various overlapping relationships; late in life this theme was developed in what became his first published novel, *Jules et Jim* (1953), in which diary notes recording a visit to Germany in 1907 supplied the material for exploring the psychology of the three main characters. A similar approach based on life lay behind his second published novel, *Les deux anglaises et le continent* (1956), as too *Victor* which would have formed a third instalment in this semi-fictionalised autobiography; the latter is an unfinished work, however, since Roché died before completing it.

The number of textual variants noted in the published edition does not in fact run to many at all, and in a similar filtering the translation here does not trouble with the more minor variant readings (e.g. at the end of Chapter V, "exhausted" might have seen the light of day as "falling asleep") where this makes negligible difference to what is after all a draft, concentrating only on the more significant variants provided. It is interesting to note that the longer of these passages which

Left: first page of the French manuscript of Victor.

had been crossed out by Roché quite often seem to offer greater insight into events, suggesting that in the course of his revision he felt he was saying too much. In a letter to Roché congratulating him on the publication of *Jules et Jim*, Duchamp wrote that in enjoying the book he found it "very compelling in its deliberately simplified style"[1] and this is a trait very much in evidence in *Victor* as well, even in the state of the text as it has come down to us. The deliberate paring-down in the manuscript would result in a narrative paced even more by understatement in which overt analysis would be considered an unwarranted intrusion.[2] This is most marked in Pierre's speech, in some lines of which a clipped staccato almost makes him into a Hemingway hero, though here also we find that the dialogue is characterised in general by its frankness,[3] whether Pierre's concision, Victor not spending more time than necessary on it or Patricia expressing herself bluntly and directly even as she skips from one topic to another.

While allowing for Roché's laconic style we can see in this fragmentary text that certain sequences are more developed, others left more in outline (particularly in the second half), with a running narrative connection almost wholly absent. We shall almost certainly never know how close, or far this manuscript stands in comparison with the finished work as envisaged, although there are a few clues in a list of women "we shall encounter again" (p.52) and in the schema at the end with its hints concerning overall plotting and the mapping of a code of living, or the authorial dissatisfaction with which the second notebook begins. Most intriguing is Clair's cute but throwaway remark[4] that Roché's writings are "a delay in prose" in the same way that Duchamp's *Large Glass* is "a delay in glass", but regrettably this is something only the late author could have made clear to us.

1. Letter dated 15 May 1953, as published in *Affectionately, Marcel*, p.324.

2. A more enthusiastic letter from Duchamp upon receiving a copy of *Deux anglaises* picks up on this again, in which he tells Roché that "the trick is not to spoil the explosion with reflections" (5 June 1956, *Affectionately*, p.348/9). Jean Clair was of the opinion that Roché and Duchamp had this general dryness of style in common, as well as their being alike in physical appearance (*Victor*, Pompidou, p.7).

3. Clair speculates (*id.*, p.8) as to whether this openness indicates cynicism, innocence or (in the French way of things) both at the same time; this is unnecessary, it is merely the characters' voices.

4. *Id.*, p.5.

VICTOR
Cast in order of appearance

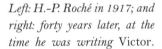

Left: H.-P. Roché in 1917; and right: forty years later, at the time he was writing Victor.

Pierre = Henri-Pierre Roché (1879-1959). The author of *Victor*, known as Pierre Roché by his friends, was a congenial individual who spent much of his life as an informal art-dealer and adviser to art collectors. His activities as a promoter of modern art played a significant role in its history, for example, it was he who introduced Picasso to Leo and Gertrude Stein in 1905 and encouraged them to buy his paintings. He was an adviser to John Quinn (see Harold, below) and to Katherine Dreier (Gertrude, below), and after WWI, in Paris, to Jacques Doucet (along with André Breton). These collections alone would tell most of the story of the great years of early modernism. In 1948, he was a founding member of Dubuffet's Compagnie de l'Art brut.

Meanwhile, Roché's extensive diaries record a personal life of unusual complexity. The triangular relationship recorded in *Victor* (with Marcel Duchamp and Beatrice Wood) was by no means the only one in which he was involved, then or in later years, and his two best-known novels, *Jules et Jim* and *Deux anglaises et le continent*, record similar situations. His writings were in fact voluminous and include numerous lightly disguised autobiographical explorations of such baroque sexual relationships. Most remain unpublished, although his first book to appear came out pseudonymously, in 1921 with the title *Don Juan and...*

The complications of Roché's love affairs go far beyond anything as simple as

"philandering" (see, for example, Geneviève, below). He made considered, if convenient decisions in regard to this aspect of his life and read widely in the fields of psychology and ethnology to support his penchant for polyamorous relationships. His biographer (in a particularly good French Wikipedia entry) supposes that he was in fact taking a step onwards from what Duchamp would do with his readymades, and made his life itself into a work of art. This could make his diaries the equivalent of his "Green Box", and *Victor* perhaps his *Large Glass*. Duchamp and Roché remained close friends until the latter's death.

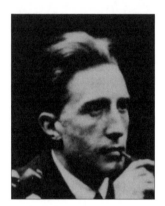

Victor = Marcel Duchamp (1887-1968). While it is unnecessary to summarise Duchamp's artistic career here, it is perhaps worth recalling that he was already something of a celebrity on his arrival in New York in 1915. This was because of the notoriety stirred up by his painting *Nude Descending a Staircase, No. 2* during the International Exhibition of Modern Art or "Armory Show" of 1913. This large exhibition provided the first sight of modern art to New Yorkers: Picasso, Braque, Matisse… but it was Duchamp's painting (unknown in Europe) that provoked the most controversy. Duchamp himself did not attend the exhibition.

François = Francis Picabia (1879-1953). Picabia, being slightly older than his Dadaist contemporaries, was a key figure in the movement and a great proselytiser for the more advanced forms of modern art at this time. He was at once an artist, writer and the editor and publisher of the eccentric magazine *391*, which was published from wherever Picabia, an inveterate traveller, happened to be. It was this internationalism which made it an essential organ for the new art, and Picabia's acerbic humour and often mischievous criticism ensured it was widely read in the circles that mattered.

Patricia = Beatrice Wood (1893-1998). Beatrice Wood came from a wealthy New York family, and was educated in France between the ages of 7 and 12, returning to Paris in her late teens to study at the Académie Julian (Roché had studied there too, some years earlier). "Patricia" was Beatrice Wood's stage name, and while in New York at the time of *Victor*, she performed in a French-language theatre in Manhattan. However, neither of these careers, as artist or actor, proved successful in the long run. In 1918, towards the end of the events recounted in *Victor*, she married Paul Ransom (presumably Auguste on p.110), her theatre director at the French Theatre in Montreal, and they moved back to New York in 1920. The marriage was unhappy and ended soon afterwards, in part due to her husband borrowing money from the Arensbergs. In the 1940s she took up ceramics and over the next 50 years acquired a considerable reputation in this field. We at Atlas Press were pleased, and not a little surprised, to receive an order from her for our newly published *4 Dada Suicides* in 1995, when she was 102.

On page 52 Roché refers to sections of this novel yet to be written that will introduce various characters, some of whom, in the event, never made it into the book. Three of the most important of those named are:

Alissa = Alissa Frank. A journalist friend of Beatrice Wood's who later had an affair with Roché. It was Alissa Frank who suggested that Wood, a French-speaker, should visit Edgar Varèse in hospital, where she met Duchamp for the first time.

Yvonne = Yvonne Chastel. Chastel was the ex-wife of the painter Jean Crotti, who married Duchamp's sister after their divorce. She, in turn, had her sights set on Marcel.

Lou, Louise = Louise Norton, née Louise McCutcheon, then Louise Varèse (1890-1989). Just before the events recounted in *Victor*, Louise Norton had been co-editor with her husband Allen of the New York periodical *Rogue*. This

somewhat louche publication combined modernist authors such as Apollinaire, Gertrude Stein and Mina Loy with a visual aesthetic closer to the 1890s than the era of Dadaism. Its final issue appeared in December 1916 and the Nortons separated around the same time. Louise subsequently became friendly with Duchamp and Roché (see entry for 18 April 1917 in the Chronology) and wrote the most important text defending Duchamp's *Fountain* in *The Blind Man.* Indeed, one suspects she played a significant editorial

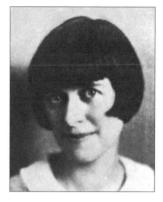

role in the second issue of the magazine, since many of its authors had previously been contributors to *Rogue.* She married Edgar Varèse in 1922 and became well known as a translator, particularly of Rimbaud. In her later years she was a close friend of Frank Zappa.

Pascin = Jules Pascin (1885-1930). A French artist known principally for his delicate pastels and watercolours, usually of partially robed female models, he was in the USA so as to avoid the war. On his return to Paris he became a pivotal figure in bohemian circles and was known as the "Prince of Montparnasse".

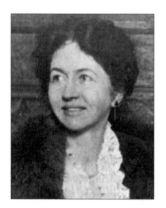

Alice = Louise Arensberg, née Mary Louise Stevens (1879–1953). Louise Arensberg was the heiress to the New England Stevens's textile fortune. Her interests were musical in the main, and she played the piano well but not in public. She indulged her husband's art collecting and presumably helped to fund it. Her marriage survived her two-year affair with Roché, although Walter several times threatened suicide if she left him. In 1921 she insisted they make a new start and relocate to California, which brought an end to their salon in New York. The couple had no children and eventually presented their enormous art collection, which included most of the works of Marcel Duchamp, to the Philadelphia Museum of Art (it had been declined by various other museums in the USA).

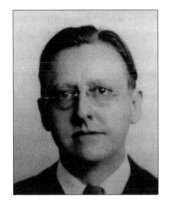

Gontran = Walter Arensberg (1878-1954). Walter Arensberg was also well-off, if not quite so fulsomely as his wife: his parents had owned a Pittsburgh steel business. It was he who assembled the couple's art collection and he was also a serious poet, his early verse being influenced by French Symbolism (*Poems*, published in 1914). His later, more interesting poetry, in which one can detect Duchamp and Picabia's notions of a "mechanical" art, has not been collected, although some in this mode appear in *The Blind Man*. His interests soon moved on from poetry to a patently absurd decryption of the works of Shakespeare in which he repeatedly manages to find the name of Francis Bacon concealed in the text.

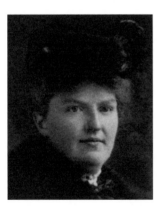

Gertrude = Katherine Dreier (1877-1952). An amateur painter and wealthy patron of the arts, she founded, and funded, the Société Anonyme with Man Ray and Duchamp, which sponsored lectures, concerts, publications and exhibitions of modern art. The society's collection was given to Yale University Art Gallery in 1941. Dreier was thought rather stolid in attitude, and not a few writers have described her, rather unfairly, as the Margaret Dumont to Duchamp's Groucho.

Sabine = in all probability, Mina Loy (1882-1966). A painter and poet, she had recently returned to New York and had been both writing and acting in "avant-garde plays" as described in *Victor* (p.59). Loy was born in London and spent her twenties and thirties as an art student in Paris, an *habituée* of bohemian circles and Gertrude Stein's salon in particular, then in Florence where she was associated with the Futurists and had a brief affair with Marinetti. On the outbreak

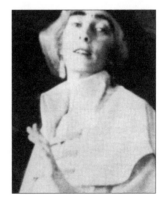

of war she became a surgical nurse, before leaving for New York where so many of her friends had ended up. A contributor to both *Others* and *Rogue*, she was soon a regular at the Arensbergs'. She met Arthur Cravan at The Blindman's Ball and despite her initial revulsion married him in Mexico City in 1918. Soon afterwards Cravan disappeared on his way to join her in Buenos Aires; she spent most of the rest of her life in New York or Paris. Her poems are collected in *The Last Lunar Baedeker* (Jargon Society, 1982).

Jérôme is described as being a critic, and so may well be Henry McBride (1867-1962), although he was not a great regular at the Arensbergs' salons. McBride was close to the Stettheimer sisters, however, who were particular friends of Duchamp's. He and McBride collaborated on the latter's book of criticism, *Some French Moderns Says McBride* (1922), which Duchamp designed and which was published by Dreier's Société Anonyme.

Sigismond has not been identified.

Taty, Mme François = Gabrielle Buffet-Picabia (1881-1985). Gabrielle (Gabrièle) Buffet was the grand-daughter of Jussieu, the famous French botanist; she trained in composition and counterpoint in Paris and Berlin, and married Francis Picabia, a friend of her brother who was also a painter, in 1909. She was fascinated by the relationship between music and abstract painting, publishing "Impressionisme musical" in *La Section d'or* (no. 1, 1912) and "Musique d'aujourd'hui" in Apollinaire's *Les soirées de Paris* (no. 22, March 1914). In 1910 she and Picabia met Duchamp, who remained a lifelong friend. Witness to the emergence of the avant-garde and Dada in Paris, New York, Barcelona and Zurich, and friends with most of those involved, she wrote about Picabia, Cravan, Arp, Duchamp and others; her text on Apollinaire is still the best

introduction to the poet. A collection of her writings, *Aires abstraites*, was published in 1957. She had four children with Picabia, whom she divorced in 1930.

Arthur Cravan (1887-1918?). This larger-than-life "Dadaist boxer" led a provocative existence as a vagabond around Europe before ending up in Paris before the War. Here he acquired a cause and a magazine, *Maintenant...* [Now], which although disguised as a critical review was actually devoted to offending as much of the new establishment of modernists as its editor and sole author could manage. Cravan was remarkably successful in this and his large physique was no doubt an asset in the ensuing quarrels. On his way out of Europe to escape WWI, he and Jack Johnson, until recently the world heavyweight champion, found themselves broke in Barcelona. A match was arranged to raise funds and Cravan, reputedly drunk, threw the fight in the sixth round. In New York he met Mina Loy and they married in Mexico not long after. Buenos Aires was next on the itinerary: Loy, already pregnant, went on ahead, but it seems that Cravan, broke yet again, attempted to cross the Bay of Mexico in a small sail-boat and was lost at sea. Subsequent sightings in Europe were never confirmed. After his death his activities were quickly recognised as a precursor of Dada. His writings are available in English in *4 Dada Suicides* (Atlas Press, 1995).

Arthur B. Frost, Jr. (1887-1917). Having inherited the technical abilities of his father, a celebrated and very successful illustrator and sporting painter, he was taken by his parents to Paris to train at the Académie Julian. Here he was infected with modernism (chiefly the Fauves, and Delaunay's Orphism) and was afterwards associated with the Synchromists in New York. He died suddenly, not long after his bout with Cravan (see p.65), on 7 December 1917, seemingly of tuberculosis.

Albert Gleizes (1881-1953). With Gris and Metzinger, Gleizes was one of the second generation of Cubist painters that helped swell Picasso and Braque's experiments into a fully-fledged "movement". He exhibited at both the Armory

Show and the New York Independents, and was one of the main theorists of Cubism; his writings were extensive, particularly after WWI, when they became influential at the Bauhaus.

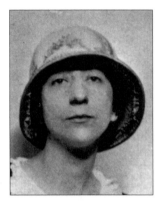

Juliette Gleizes (1884–1980). Albert Gleizes's wife Juliette was also a painter and a poet. She later wrote a *roman à clef* of her time in New York called *The Mineralisation of Douglas Craving MacAdam*, which Atlas Press intends to publish soon. It expresses a gradual disillusionment with the social scene they discovered, since the Gleizes felt the bohemian high-life of the Arensberg circle to be a little over-ripe and soon moved to a suburb outside New York. Following WWI, they led a life devoted to art and poetry, mostly in the south of France.

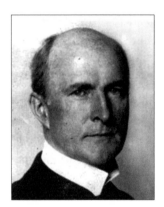

Harold = John Quinn (1870–1924). By profession a corporate lawyer, Quinn was probably the most important modern art and book collector of the period; he became friendly with both Duchamp and Roché, who supplemented their minuscule incomes with some art-dealing on Quinn's behalf. Roché had first met Quinn in Paris in 1911, and entered a formal business relationship with him in 1920. Quinn had been one of the organisers of the Armory Show in 1913, and was also close to Ezra Pound. He deployed his legal skills in favour of the Irish nationalist cause and for various artistic controversies, such as the defence of Joyce's *Ulysses* on charges of obscenity.

Geneviève, Roché's Parisian lover, cannot be identified with complete certainty but is probably Germaine Bonnard, with whom he had had a relationship since 1912. In 1927 she came across his diaries and thus the extent of his infidelities, and

insisted that he marry her (an unusual reaction perhaps to such a discovery). Roché consented, although he was also in another permanent relationship that had already lasted for seven years (with the model for the woman in *Jules et Jim*), and which he had no intention of ending. He commenced a third soon after the marriage. All three women were party to this "arrangement".

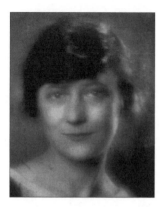

Mary = Mary Reynolds, née Mary Hubachek (1891-1950). Originally from a comfortably-off family in Minneapolis, Reynolds moved to Paris after the death of her husband from influenza at the end of WWI. She became well known in Montparnasse bohemian circles, being close to Peggy Guggenheim and Djuna Barnes, and worked as a book-binder. Duchamp's relationship with her began in 1924 and lasted for some 30 years, although often in the unenviable circumstances she describes in chapter XXIV of *Victor*. An active resistant during World War Two, she narrowly escaped arrest and execution.

Winifred, "a young widow" Victor was comforting, has not been identified.

Isadora Duncan (1877 -1927). American dancer, "the mother of Modern Dance", who in her lifetime perhaps became as famous for her unconventional, and often tragic private life as for her dancing. This notoriety, in the USA at least, was only magnified by her espousal of leftist politics after 1921. Her death (she was strangled by one of her long scarves while driving in an open-top sports-car) seemed to many to personify a life lived at full speed.

Auguste = Paul Ransom, see entry for Beatrice Wood above.

HENRI-PIERRE ROCHÉ

Victor
(Marcel Duchamp)

Translated by Chris Allen

Marcel Duchamp in 1917, photograph by Edward Steichen.

That which hath been is now.[1]

1. Eccles. 3, 15, in the phrasing of the Vulgate translation of 1759 by Maistre de Saci; this first part of chapter 3 in Ecclesiastes lists examples of the appointed times for all things, a time to be born and a time to die &c., and culminates in the phrase chosen by Roché. [Trans.]

I

Pierre is alone in his square, well-heated basement room. It is more of a cellar that he is using as a bedroom. Through a horizontal window near the ceiling he can see the legs of passers-by. Incongruous pieces of old furniture, but a nice big iron bed for two.

Footsteps crunch in the snow. A sharp knock at the door. It is midnight. Victor and François breeze in with a dark and mischievous-looking girl[3] they are holding securely by an arm each. Her large black eyes are blazing with anger.

Victor. "May we introduce our friend Patricia. She made a stupid scene in the Café Brevoort when François and I needed to talk."

François. "We gave her a choice between two punishments, a mouthful of castor oil (which they sell in the café) or you. We described you, and it was you she opted for. She says she'll talk to you about what she did because you are a gentleman. She's an actress. If things take a bad turn, lock that iron letter-opener away in a drawer. If the police turn up, give Patricia the bed in the box-room next door. It's got a separate entrance along the corridor — you let me use it once before — and can be locked from the inside."

At first Pierre was annoyed at them bursting in. He was about to go to bed and had to get up early. He and Patricia sized each other up.

2. MS. dated 10 February 1957, in the first of two notebooks in which *Victor* was written. [Trans.]

3. In English, as Roché often does throughout; similarly "gentleman", "talk", "lunch" and "Public Library". [Trans.]

Victor. "We haven't brought her just on a whim, there are reasons."

Patricia. "I know you two. You never do anything flighty, in spite of your Pegasus ways. You're like a pair of popes. I should have soaked you with the siphon in the café. All right, go away now and leave me be."

Pierre. "OK. I'll look after Patricia."

The two of them dashed out without saying good-bye and Pierre heard François's sports-car driving off.

Patricia walked around the room.

Patricia. "I like this crazy room. You need some chairs in here. *Foutons-nous*[4] on your bed like it's a sofa — it was Victor who touched up my French — I mean, you in the bed and me on it. We both love him so there's no danger. And let's talk about him."

With that she jumped on to Pierre's bed. They settled down some distance apart and just as she had said.

Patricia. "Victor invited me out this evening. I thought I might find him alone at last. François comes up, all offended. He sat down beside me. They started talking about their stuff. I ruined their evening on purpose. I made a scene in the café by asking questions about anarchists in a rasping voice you could've heard right from the other end of the room. The people next to us got a bit worked up, called the manager over and insisted he call the cops. I turned up the volume, I was enjoying it, I wanted the police to come and take François away. They talked it over, and then asked us to leave. So, we had to leave. As a punishment, they bundled me up and brought me here."

Pierre. "Do you love Victor?"

Patricia. "Yes."

Pierre. "Like or love?"

Patricia. "Both. Mostly love."

Pierre. "A chaste love?"

4. A verb to describe slinging a coat into a corner, for example, but also used indecently, so here something like "Let's chuck ourselves on your bed" (no connection with *futon* though). [Trans.]

Patricia. "Alas! I'm completely in love and without the slightest hope. I don't know what you'd call that.

"Everyone loves him. He belongs to everybody and to nobody. He's probably right about that. I've got no right to want him for myself, but I don't want anyone else.

"Victor could find himself an heiress. Not a chance. Could get a hefty return for his paintings. Not a chance. He virtually gives them to his friends. He also gives brilliantly entertaining French lessons, for two dollars an hour. He has fun the whole time. He has a kind smile, but he's a dictator. He only does what he wants, and when he wants. He's the centre of attention wherever he goes, he's the one in charge. His imagination is at work non-stop. There's no question that he has affairs, but with grown women, not young ladies. He is discreet, no one knows anything. He is twenty-five,[5] I'm twenty. And you?"

Pierre. "Thirty."

Patricia. "How long have you known him?"

Pierre. "Since I came to New York, a fortnight ago."

Patricia. "What do you do here?"

Pierre. "On loan from my government to an American Association."[6]

Patricia. "Hard up?"

Pierre. "Sort of, but only for a little while. Anyway I requested this posting even though it's unpaid. I have enough to get by for a month and some articles in the pipeline, and a book."

Patricia. "Where do you eat?"

Pierre. "In a non-segregated bar for subway workers. For fifteen cents. Rice pudding. Apple pie. Cup of coffee. I like the clientele there, blacks and whites.[7] They work hard and eat heartily. As do I."

5. In fact he was 29 in 1916, and Henri-Pierre Roché was 37. [The note in the French edition doesn't trouble to mention that Beatrice Wood was 23 at the time. Trans.]

6. The American Industrial Commission to France.

7. Marginal note: "Atmosphere of Walt Whitman".

Patricia. "Would you take me there? Would you show me?"

Pierre. "Women aren't allowed."

Patricia. "Victor told me that you go to the Opera House?"

Pierre. "With my bosses. Since I met Victor. I only got here recently, and I feel happy in New York. And you, Patricia?"

Patricia. "I'm not happy. I come from a well-off family, but I don't get on with them. I have one friend, my dog Zebi, a greyhound. I've done theatre, in French and English. Then my parents cut off my allowance. They haven't actually kicked me out, but I live away from them as much as I can. I earn a kind of living dyeing silks. I promised them I wouldn't make any big decisions without telling them first. I am very busy, I think about what Victor tells me, and I have two French lessons a week with him. He opens the kingdom of wisdom for me. Nothing else."

Patricia had a sad smile. There was a noise in the corridor. The landlord? Patricia fled to the box-room, the lock clicked and it was a good while before she reappeared.[8]

Pierre was smoking his pipe. She threw herself down beside him again and went on:

"Victor has no needs, no ambitions, he makes enough to live on from day to day. Nobody has a hold on him. That makes some people angry — they feel the ideas he keeps to himself could actually turn everything upside down.

"He says that he breathes deeply and just watches the world go by without wanting to influence anyone. That's all. He says that only those who have the vocation for it should have children, and that the more you own on earth, the less free you are. This *sale gosse*[9] (he taught me that) is famous, you know...? But he's got no time for that. His painting sent shockwaves right across America.[10] To the bourgeoisie he is the Devil... to others, the

8. Their fear of discovery by the landlord is explained in more detail on pp. 70 and 72. [Ed.]

9. Little brat. [Trans.]

glimmer at the end of the tunnel. He is our Prince Charming, our magician, our... Shall we use *tu*, is that all right?[11] He likes his friends to use *tu*. All right? Good.

"*Tu m'emmerdes*... Don't look so shocked. He taught me that. But only so I could practise using *tu*. How could I marry a missionary? That's what he is. He belongs to everyone, not just to one woman. I know four girls who love him almost as much as I do.

"He is selfish with his time, without even knowing it, because he finds so many things unworthy. But the other night, a young friend of ours was killed in a car crash. The man's fiancée, also a friend, lives an hour outside New York. Such sweethearts. Victor said, 'I'll go and tell her.' He caught the dawn train, and when she opened her shutters she saw him, walking about in her garden. He spoke to her. I don't know what he said but later she told me, 'I owe it to him that my life hasn't fallen to pieces.'

"He forgets anything which doesn't really touch him deeply.[12] He says that everything filters through on its own and that you have to let things flow. On the other hand, he is always two minutes early for his lessons, even with me.

"I'm hungry."

Pierre jumped out of bed and brought back two pots of curd cheese, some brown bread and two yellow apples. Their teeth squeaked.

Patricia. "Did Victor tell you? This is what I usually eat."

Her voice was expressive, warm and rich. She articulated her words perfectly. Pierre asked what parts she had played in the theatre.

Patricia. "No. Another time. Tonight we're talking about Victor. Have you

10. *Nude Descending a Staircase, No. 2*, exhibited at the Armory Show in 1913.

11. "*Tutoyons-nous, voulez-vous?*" i.e. shall we use the more familiar "*tu*" with each other, rather than the formal "*vous*" of first acquaintance; a reminder that these conversations are taking place in French. The next paragraph then begins "You piss me off...". [Trans.]

12. MS. variant: "He forgets appointments he doesn't think are important. On top of that, he gives (var. takes) as little of himself as he can."

ever slept with an American?"

"Not *an* American, only with two at the same time."

"I don't believe you! Tell me about it!"

"Last week. Two pretty girls, sisters. Their room is on the top floor. In the morning they asked me if they could leave a heavy package in my room for an hour. It was midnight when they came back. They said, 'Mister, you look like an honest kind of guy.' 'Thank you.' 'We came to New York to be music-hall dancers. Our future depends on that. We're taking the final classes now. We're exhausted. Rats keep us awake all night. They come into our room from the balcony. A cousin here in New York lent us his air-pistol to shoot them, but we keep missing and they come really close. Could you come and help us!'

"I went upstairs and we got ourselves organised. When we heard a rat, one of the sisters switched on the light, the other brandished a broom-stick, and I fired. I killed two. The sister with the stick picked them up by their tails and threw them out into the street. I hit another one but it got away.

"But more rats came. We blocked up the biggest holes from the balcony with some old bags we screwed up into balls. When that was done all five of us got into the big bed and slept well."

"All five!"

"Yes, the two sisters, the pistol, the broom-stick and me."

"Phew! I'm relieved to hear that. You were born to protect us girls. Isn't there a Greek name that means that?"

"They promised me seats for the show, if they get the job."

"Will you take me?"

"Of course."

"Did they smell nice?"

"They smelled of rosy, rustic bodies."

And so they carried on...

II

Around five o'clock in the morning they heard François's car again. There was a knock.

Patricia jumped up, unbolted the door and called out "Come in", then got back on the bed. Victor and François entered, looking serious. They smiled when they saw how Patricia and Pierre had got settled.

"I have a couple of things to ask of you," said Victor. "We're going to start a magazine. We're picking ten friends, you two included, to write or illustrate what you want. And then we'll publish it.

"Everyone will be responsible for a different part. The paper for the first issue is going to cost us forty dollars. We'll get that from advertisements. Patricia and Pierre, can you take care of securing those? Yes? Good. Here's a list of addresses. Would you also see to registering our magazine?"

"Yes," said Patricia.

"Yes," said Pierre. "But I'm only free after five during the day."

"That won't be a problem," said Victor. "The second thing: in a week's time there's a Florentine ball at the Vanderbilt. Patricia, I don't want to take you along, but between now and then could you make Pierre a costume, if he'd like to come? (Pierre nodded.) He's not very well-off at the moment. Can you borrow your brother's grey outfit and make a quilted doublet?"

"Consider it done!" said Patricia with a smile.

"We did the right thing bringing her here," said François.

Patricia offered them yoghurt and apples.

"There isn't time, Patricia! We're taking you back home!"

They left holding her by the arms as they had when they came in, but this time as a joke. She glanced at Pierre. He had fallen asleep.

Two days later, Patricia telephoned to say she was coming round, and arrived with a package.

She pulled out some material, tailor's shears and a grey outfit of her brother's.

"Put that on quickly, in the box-room. And tell me if it's too tight."

It was very close-fitting. The legs and feet were short, but passable.

"It's perfect," she announced. "Now I'm going to cut out your coat." She unfolded the pale fabric, draped it about Pierre and marked some lines on it with tailor's chalk. Then she cut it out smartly with long sweeps of the shears, laid it flat on the table and began drawing some bold but simple designs on it with bananas here and there.

"I make my stage costumes myself," she said. "It doesn't take a minute. I'll take you along now to my dyeing studio and we'll give this some colour."

They took the Elevated, the one that screeched round the corner outside Pierre's room, till they came to a street with low houses.

They entered a large, dilapidated room, with small tubs and a bare table stained with many colours like a palette.

She threw in her powders, soaked, wrung and blocked out, painted and hung up to dry. She was a sorceress inspired, splashing colour on her bare arms and even her face. Her rubber apron was dripping. She was a native Indian on the war-path. From time to time she swore a powerful oath Victor had taught her.

"I'm going back to my place like this. I don't care one way or another about people in the street, but I'll only say hello to my mother after I've had a bath."

The next day, she came to see how the coat looked on Pierre. It was a work of art. He told her that.

"No bad language, please," she said. "As you can see, I've made the neck quite high because Victor said you can't stand the cold."

"What a pity, Patricia, that you're not coming to this ball!"

"It doesn't matter," she said.

III

Patricia and Pierre arrived at the Registration Office in high spirits. Both floors were being painted, and one of the painters laughed and showed them the door they wanted.

They asked for a form, and were told to fill out two copies. Without reading too much they wrote out their names and addresses and the name of the magazine, signed the forms and handed them back to the clerk. The latter read and said, "Why have both of you written 'The Blindman' at the top?"

"Because that's the name of the Magazine."

"What magazine?"

"The one we've come to register."

"But these are marriage licences!"

"Damn!" said Patricia, sucking her pen, "let's think about this first." She looked at Pierre in a Napoleonic way and drew him aside a couple of steps. "I would marry you at a push, but it's Victor I love, even though there isn't the slightest chance with him, and anyway, you've got your Parisienne waiting for you. You've only mentioned her a few times but I feel fond of her."

"Excuse me," Patricia said to the clerk, "where do we have to go to register our Magazine?"

"Door 12, the floor below."

They went down and filled out the registration. The joker of a painter waved his brush.

IV

At François's place. Victor challenged Pierre to a game of chess. Pierre quickly realised that he couldn't compete against Victor and didn't ask for a re-match.

"Have a game with François then," said Victor.

The two of them settled down and began a keenly fought contest with unexpected pitfalls and an intensity that held them completely absorbed. Victor was following it out of the corner of his eye. Then he began taking notes, which caught the attention of both players, who were pretty much evenly matched.

They were surprised, a month later, to find their game published in the Magazine![13] One reader, a professional player, wrote in to ask why "such a thing" had been published. Victor replied that the match was newsworthy because it came straight from daily life, and because it was lyrical, heroic and romantic with its inadvertent copying of famous positions, its sudden mysterious panics, overflowing with imagination and even, now and again, a good move. In short it was proof that, even without any special technical knowledge, high emotions could be a part of chess too.

13. It was actually published in *Rongwrong* (July 1917), see opposite. [Ed.]

À DOUXAMI

mais surtout à tous ceux qui savent.

———

PLAFONDS CREUX.

———

Pourquoi comme un vieillard monstre

Dans ce cimetière de loques

Avec ton Turban de cercueils

Stérile culture des herbes grossières

Incompréhensible gymnasiarque

Remous domestiques

Lampion

Ne vois tu pas ennemi de la lumière

Que je suis la vertu génie.

 Picabia.

UNE NUIT CHINOISE À NEW YORK

———

Saleté Silence Vide Ennui

Musique soudaine rire bruit,

Manque d'opium, manque de viande,

Manque de poésie, manque de joie.

Grand chahut, grand tumulte,

Faim énorme, vide immense,

Poulet froid, eau glacée,

Bêtes affreuses, femmes jolies,

Regards doux, faim envolée.

C'est PHARAMOUSSE, c'est l'Amérique.

 —Marquis de la Torre.

	White Picabia 391	Black Roche Blindman
1	P—KR 4	P—K 4
2	P—Q 3	P—Q 4
3	P—R 5	P—Q 5
4	P—K 3	P—K B 4
5	P—K 4	P—K B 5
6	P—K Kt 3	P—K Kt 4
7	Kt P×P	Kt P×P
8	B—R 3	Kt—Q B 3
9	B×B	R×B
10	Kt—K B 3	Q—K B 3
11	P—Q B 3	R—Q 1
12	Q—Kt 3	P—R 3
13	P×P	Kt×P
14	Kt×Kt	R×Kt
15	B—K 3	P×B
16	P×P	R—Kt 5
17	Q—R 3	P—R 4
18	Q—B 3	B—Q 3
19	Q—B 6, ch.	K—K 3
20	Kt—B 3	K—K B 2
21	Kt—Q 5	Kt—K 2
22	Q—Q 7	Q—Kt 4
23	R—B 1, ch.	K—Kt 2
24	K—Q 2	R×P, ch.
25	K—B 3	R—B 1
26	R—K Kt 1	Q×R
27	R×Q, ch.	K—B 2
28	R—B 1, ch.	K—Kt 2
29	Q—Kt 4, ch.	Kt—Kt 3
30	R×R	B×R
31	K×R	K—R 3
32	P×Kt	P×P
33	Q—R 3, ch.	K—Kt 2
34	Kt×P	Resigns

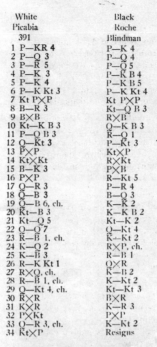

CLIFFORD WILLIAMS
(Plâtre à toucher chez De Zayas)

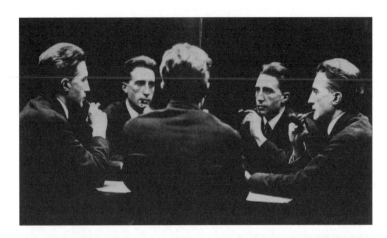

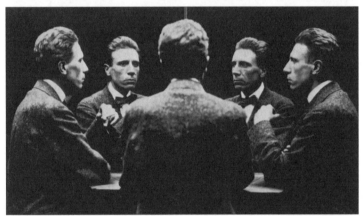

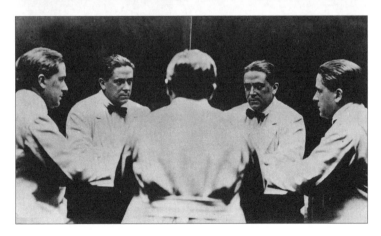

V

The Ball

Victor, dressed as an astronomer, and Pierre as a nobleman, in Patricia's dazzling tunic, arrived at the still almost empty halls of the Vanderbilt. It was chilly and the two Frenchmen sat on the floor with their backs against the radiators. Couples were coming in, young and brisk. Their costumes were from some imaginary Middle Ages.

A slim blonde came and sat down on the floor beside Victor. Then a brunette. Before long there were a dozen women. They beckoned to their partners, several of whom came over to join them.

Victor smiled his Prince Charming smile. He chatted calmly with everyone. Most of them were French students of his. He noticed that Pierre was being left out and delegated a couple of girls to keep him entertained.

Finding him a little out of touch with things, they told him all about Victor in New York — a young prophet against his will, untouched by ambition, both revered and disparaged, who overturned many an ancient idol with a single word. To some the Devil, to others the deliverer. No one understood him, he was opposed to every kind of habitual practice, yet he drew everyone's heart along in his wake. Together with Napoleon and Sarah Bernhardt, he was the most famous French person in America.

Pierre thought Victor deserved his fame, but he found it remarkable even so. It was a memorable evening and he'd witnessed it all with his own eyes.[14]

14. Two sentences have been cut here: "A miracle brought about by clarity of vision based upon clarity of thought. One day he would write it down."

Left: Marcel Duchamp, Henri-Pierre Roché, Francis Picabia.

Victor didn't dance. He took no pleasure in such external rhythms.

His faithful followers got up and danced frequently, their places being quickly taken, then they would come and sit down again not far from him. A gentle ballet, like a large flower made of fresh dresses renewing itself.

He had beauty, and a central negating idea that was incendiary. He negated the way all of us use our time.

They had beauty and curiosity, and in his company they really felt that their whole culture was tottering and in need of being reassessed.

Pierre could hardly imagine such an unqualified success in London, Berlin or Paris, and he admired these American girls.

So what was Victor's secret? That evening he brought to mind a young Bonaparte, an adolescent Alexander the Great, or the Hermes by Praxiteles.

Pierre felt a tickle on his neck. He moved his hand to it but there was nothing there. It happened again. He turned around quickly and saw a Hottentot Venus, padded out with wadding and with a black stare, with a necklace of ruffled feathers, an ostrich feather in her hair and another one in her hand. It was the cigarette-girl, in costume as well. A third tickle. She really had it in for him. He looked her in the eyes. It was Patricia!

She put a finger to her lips and moved away. She had found a way to get in, wanting to see Victor holding court with his usual freedom, but without being seen by him.

It was hot now and Victor had migrated towards a large corner sofa, with girls on his right and left and sitting on cushions on the floor.

(Here, Pierre and Patricia's little talk. She points out and comments on certain of the women we shall encounter again later. Alissa, Winifred, Petite Suisse, Yvonne, Lady Iphigenia, Françoise, Lou, Mary Sturgess, Aileen, Katherine Dreier, her sister, the three Stettheimers etc.)

She said: "I don't think he had anything against my coming here, otherwise I wouldn't have come. I wasn't part of his plans for today, that's

all. Perhaps he was afraid I would make one of my scenes. But I can behave when I want to. Nobody has recognised me in all this padding that's making me sweat so much. I'm selling the cigarettes for charity."

The ball only ended with the dawn. Whisky had inspired fools to Shakespearean antics, and provoked some comical incidents.

But it was too soon for Victor's young admirers. A redhead with a diadem suggested going back to her place for a nap, then oysters and lobsters for lunch, and carrying on for the rest of Sunday. Agreed with cheers.

Fifteen of them left.

They dined, supping in one another's apartments.

After that, it was time for the bars. By midnight there were only ten of them, Victor, Pierre and four couples.

Victor was the touring idol and insisted on paying everywhere they went. He was euphoric, and tipsy. Two of his friends would take the money from his bottomless pocket, because in fact they were refilling it and paying for him.

Suddenly another gang of disciples, men and women, just as spent, entered the bar, following their own prophet, just as authentic, the dashingly handsome painter Pascin. He was the only one in his field who could be compared to Victor, by the example he set and the conversions he brought about.

The two heroes found themselves face to face and there and then, exhausted, made as if to slap each other twice, but without making any real contact, each renouncing the other according to the principle of Genghis Khan: "For there was but one Khan alone beneath the vault of heaven." Then they smiled and moved apart. Pierre was the only one to see it.

VI

Patricia and Pierre were having trouble collecting the forty dollars for the paper for the Magazine. People were asking what it would look like. Victor had said: "The like of it has never been seen before." They could only repeat that. People were asking if it would come out every month or quarterly. Victor had said: "Well, we shall see. All we're concerned about is a first issue." In the end it was Patricia's belief and Victor's influence with a friend which convinced Desti cigarettes and Preston Sturgess[15] to place the advertisements which rescued them.[16]

The first issue came out in time for the opening of the first "Independents" show in New York, which had been instigated by Victor. The title was "The Blind Man".[17] On the cover was a drawing by Alfred Frueh of a dog dragging a blind man through a gallery of paintings. Apart from one which didn't really fit, the articles were free expressions of pure fancy and a challenge to the orthodox.

The latter would seek their revenge.

Patricia and a friend were to walk up and down in front of the entrance to the exhibition dressed as sandwich-women sporting provocative posters. A stop was put to that.

A pretty salesgirl was to offer people the magazine, at a minimal price, right by the tills, at the point when they had their money in their hands. A stop was put to that.

15. *Sic.* [Trans.]

16. Marginal note: "Write up account of the first issue of the *Blind Man*."

17. Here in French as "*L'Aveugle*", so no indication of whether one word or two (as it occurs in the previous marginal note). [Trans.]

Installation view of the first exhibition of the Society of Independent Artists
at the Grand Central Palace in New York, April 1917. (Pach Brothers, photographers)

The stack of magazines was placed all on its own on a table where it got bored. Nobody touched them. A bookseller friend sold it in his shop. It has since become a collector's item.

Annoyed by such timidity, Victor demonstrated to the Independents that they were nothing of the sort by exhibiting a white porcelain urinal, placed horizontally and signed with a pseudonym,[18] which was concealed in a special cupboard.

A sculpture by Brancusi for blind people was exhibited, unseen inside a bag with two sleeves, to be felt by passing hands.

"Let us die and be born again," Victor announced. "Let us put together another magazine." The second magazine, even more fanciful and brilliant and edited by Victor's female friends, was called *"Rong-Wrong"* and ran to two issues.[19]

18. The famous *Fountain*, signed R. Mutt. [By "horizontally" Roché of course means that the urinal was exhibited lying on its back. Trans.]

19. A similar confusion to note 13, *The Blind Man* had two issues, *Rongwrong* one. [Ed.]

VII

"You haven't slept with any Americans," Patricia said to Pierre, "but have you kissed any?"

"Yes, one. In Paris."

"Tell me about it."

"It was a month ago. I was in the foyer of the American Express building, writing. A woman came and sat down at the desk opposite me and began writing as well. A dazzling redhead, poised and resplendent, a daughter of Titian, a redhead though not with a redhead's complexion, elegant and shapely and with dainty feet. Little by little I felt myself becoming attracted to her and soon stopped writing. I was looking at her hand and then it stopped too.

"The security guard announced, 'We're closing.' She stood up without a glance and walked over to the stairs.

"Was I to lose her? What was I to do?

"She paused and raised a hand to her eyes, the other reaching for the banister. She cried out and tottered. I rushed over. 'I'm feeling dizzy,' she said. 'It just comes over me. Put me in a taxi.'"

"Clever woman," Patricia declared.

"Her eyes looked haunted," I[20] said.

"Quite the hysteric then."

"I took her arm. We went downstairs one step at a time. I got in a nice taxi with her and we ran over to her place, sitting in silence. 'Give me your card,' she said, 'I'll write and thank you.'

"A doorman in braided uniform made a big fuss of her.

20. *Sic* – rather than "Pierre". Unremarked upon in the French edition. [Trans.]

"A week later, her letter arrived. 'My eyes are better. Will you come for tea on Thursday?'

"I went along. She was beautiful and calm, I liked her. Our first date was at the Louvre, the second up one of the towers of Notre Dame. She was getting divorced, and was leaving in a week. Terribly reserved. On the last day though, in the lift at the Bibliothèque Mazarine and in front of the enormous mappa mundi, an hour before she left, she gave me her lips."

"A woman on the stairs! And then?"

"She's coming back to New York in a month."

"I might have guessed," said Patricia, with a stormy look in her eyes.

VIII

The Dinner

Victor took Pierre along with him for dinner at Alice and Gontran's place. The regulars were there, Patricia, Gertrude, a plump Jewish journalist, Sabine, a writer of avant-garde plays, and Jérôme, a critic. Eight altogether. Alice made her delicately nuanced introductions with a great deal of tact.

Intellect set the key note for the evening. Once again Pierre felt as though he was under observation and so waited until he had something to say. Victor stayed in the background.

Right from the soup, Patricia darted her big eyes about in all directions, tossing out faux-naïve opinions in her velvety, well-articulated voice.

She was the starter.

Gertrude, the Jewish woman, played the ball back squarely. She was plump, stocky and ready for an argument. Jérôme then pulled out his logic. Pierre outflanked it, smartly supported by Sabine.

They were discussing the topic of the day, the Independents, and also Victor. Beset with hesitations, [he had shown that there was no such thing as the total freedom to exhibit what one wanted, that it was not enough simply to call oneself emancipated in order to be so, one needed to have the instinct for it; that a urinal is not shocking in itself, it becomes an art object if you view it that way; that there is more art of this sort produced nowadays than any other.

Gontran and Jérôme then went over the affair again.

"All the same," said Gertrude, "a country that is basically Anglo-Saxon cannot be rid of its prudishness in matters concerning the lavatory with just one swipe. Rabelais wasn't from these parts. It isn't that Victor is wrong, he

is marking an era, that's all."]²¹

Victor, showing no interest, was already thinking about something else.

Alice was an excellent hostess and appeared to be enjoying herself.

A few friends arrived after the meal.

Chess-games began in corners of the large studio-salon which was decorated with modern works, three being paintings by Victor from 1912.²²

Victor played Gontran and people watched their game. Alice settled into the middle of a big sofa in front of the log fire. Patricia moved Pierre around to her right and sat him there, then sat down herself to the left of Alice. Both women were completely relaxed.

Patricia told Alice about Pierre, her visits to his flat and about the ball. Alice hoped it would all turn out nicely for them.

Pierre was amazed at his luck, all down to Victor, at being admitted into this circle so soon after having arrived in New York.

Sabine broke away from her conversation with Jérôme and came and asked Alice to sing. Alice followed her over to the grand piano where Sabine accompanied her as she sang.

Pierre seldom liked music. He was, however, very taken with Alice's voice and by watching her singing. She looked like a pink flamingo. Patricia curled up beside him to listen.

When Alice came back to the sofa Patricia gave her a kiss and Pierre did the same with his eyes. The chess-players hadn't listened to any of it. Sabine threw a cushion at Alice's feet and sat close to her knees. Alice was boxed in.

Gertrude came over to suggest to Pierre that she translate one of his articles with him and give him her advice. They arranged to meet at her address. Patricia did not like this.

21. The whole of this passage in square brackets was later cut by H.P.R. [Perhaps the insights here exceed Roché's intentions in writing a *retard en prose*. Trans.]

22. Marginal note: "*Description*. Brancusi. Princess X. The Prodigal Son. Matisse. Rousseau etc." The paintings by Duchamp can only really be *Yvonne and Magdaleine Torn in Tatters*, *Sonata* and *Dulcinea*, all three from 1911. The other paintings were only acquired by the Arensbergs a lot later.

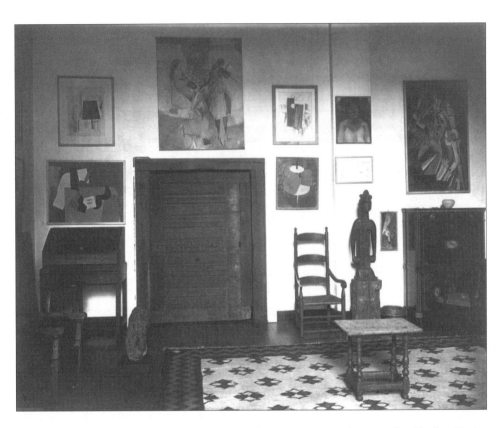

This page and next: photographs of the Arensbergs' apartment in 1918 by Charles Sheeler. Paintings visible, top row from left: Georges Braque, Still Life *(1913); Duchamp,* Sonata *(1911); Braque,* Still Life *(1913); André Derain,* Woman *(1914); Duchamp,* Nude Descending a Staircase, No. 2 *(1912-16). Bottom row: Braque,* Musical Forms *(1918); Duchamp,* Chocolate Grinder, No. 2 *(1914); Cézanne,* View of the Cathedral of Aix *(1904-6); unidentified.*

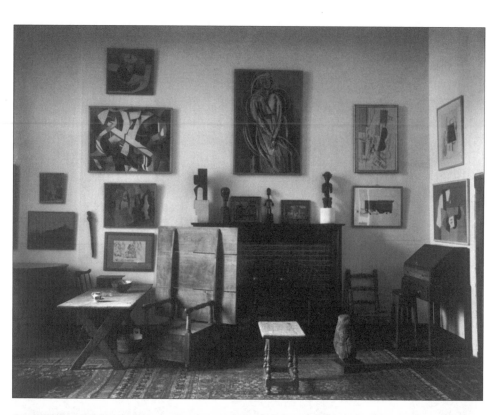

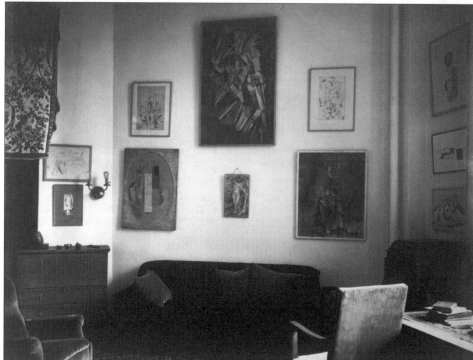

Pierre recalled his first day in New York, still so recent. He had wandered around in the vast space of Central Park and seen American soil as it had been before the City. All he ate was peanuts. He thought about the last of the Mohicans.

Then he had gone to the cinema. French troops, rushing from the trenches, had brought cries of enthusiasm from the audience. But then, next up, a parade of the Imperial German guard marching in goose-step through the midst of a burning French village elicited the same rapturous response.

Just like football.

Pierre understood: this enormous power all around him was indifferent. The war did not concern them yet (November 1916).

Upper photograph, top left: Duchamp, Chocolate Grinder, No. 1 (1913); below: Francis Picabia, Physical Culture (1913); then: Duchamp, Yvonne and Magdaleine Torn in Tatters (1911); Cézanne, Landscape with Trees (1890-94). Two small paintings to the left, above: Henri Rousseau, Village Street Scene (1909); below: Rousseau, Landscape with Cattle (undated). Above the fireplace: Henri Matisse, Mlle Yvonne Landsberg (1914). On the mantelpiece from left: Constantin Brancusi, The Prodigal Son (1914); unidentified sculpture; Cézanne, Still Life with Apples (1880-85); unidentified sculpture; Cézanne, Group of Bathers (1892-94); unidentified sculpture. To the right of the fireplace, top: Braque, Musical Forms (1913); below: Charles Sheeler, Barn Abstraction (1918). The paintings on the wall to the right are those on the left in the previous photograph.

Lower photograph, side wall to left, top: unidentified; bottom: Derain, Nude (1909). Back wall, top row, left: unidentified, but probably by Picasso; centre: Duchamp, Nude Descending a Staircase, No. 3 (1916); right: Picasso, Still Life with Bottle (1912). Bottom row, left: Picasso, Violin and Guitar (1913); centre: Pierre-Auguste Renoir, The Bather (1917-18); right: Picasso, Female Nude (1910-11). Side wall to right, top: Morton Schamberg, Mechanical Abstraction (1916); below: Sheeler, Barn Abstraction (1917); unidentified.

IX

An evening at Sigismond's, a young and brilliant Jewish fellow and a collector, with no fixed opinions. He'd invited Victor, Gontran and their friends; he tries to understand everything. The general tone was cerebral, light-hearted and good-humoured. They drank. Patricia was in a state of excitement because Sigismond wanted to commission some sort of decoration from her. François was bored. He told some dirty jokes that offended Alice. These hopeless evenings were all too familiar to her, waiting for a surprise that never comes, and when the music just feels intrusive.[23]

At her apartment, she gathered together a cluster of selected guests. This evening, the underlying theme was business. It was a place for money and talent to meet. Those who know how to adapt make money the fastest. Victor? His brow was unsullied. For him the market does not exist; he purposely remains a cobbler, not a banker.

Pierre watched. Alice was the only one he could see through. She was bored, her eyes were drifting. He went over to her and said: "This is going to go on for another two hours. You're suffering here. Me too."

He said: "Do you want to leave?" "Yes." "Right away?" "Yes." "May I come with you?" "Yes. Tell Gontran I'll send the car back."

Alice and Pierre drove slowly around Central Park for an hour and got to know each other while talking about Patricia and her attempts to escape from her mother.

23. Marginal note: "God did not create us just for our own pleasure, but to enjoy himself as well. He does not ask us to thank him."

X

An evening at François's. A furnished apartment. A bourgeois drawing-room. Twenty people, half of whom were seated on the thick carpet. François's wife Taty let things follow their own course. Her wry smile sowed seeds of freedom.

Cravan was there, the gigantic nephew (says he) of Oscar Wilde. He boxed in Spain against the world champion. He was boxing again this evening, for laughs, with the painter Frost, a tall thin man. They thumped each other's sides boisterously. People were concerned for Frost.

"Who is Cravan?" asked Patricia.

In the little periodical he used to sell at the entrance to the Indépendants in Paris, Cravan demanded that Marie Laurencin should be publicly spanked; he also invented a weird interview with André Gide.[24]

François and Pierre wrestled with each other and rolled around on the carpet. François went "Ow!" and "Oof!" like at the fairground. In the end Pierre was straddling François, his back on the floor, and holding him by the wrists.

"So what does that prove?" François said, raising his eyebrows.

"Nothing!" said Pierre, releasing François.

But François started up again, switched to jiu-jitsu and put a lock on Pierre's foot which left him at his mercy.

"And what does that prove?" asked Pierre.

"Everything!" said François.

24. Cravan published an account of this interview, which may or not have been invented, in his magazine *Maintenant...* (6 issues, 1912-15). Roché had been Laurencin's lover in 1906. [Ed.]

"That's one way of playing chess," said Victor.

"But with more dust," said Taty.

François and Gleizes fell into a discussion.

Juliette Gleizes and Patricia tried to outdo each other with the sweetness of their voices. Juliette told Alice and Mme François that Victor and François, starving one Christmas night, took a cooked leg of lamb out of her fridge in the cellar, ate it and put back the bone afterwards with a cheque attached; they only discovered this the following day when it was time to sit down and eat.

"A prank of the practical variety," said Juliette.

"We signed the loot," said François, "so that nobody else would be suspected."

In comes Harold, a blond giant, America's equal to Cravan in terms of strength. It was he who had brought Pierre over for his job. Harold was an athlete, a future millionaire, an expert on love in America and a Nordic Don Juan who knew how to make a name for himself anywhere.

He arranged to meet Pierre at midnight at the buffet in Grand Central Station to eat clam soup.

With him were a couple of pretty chicks, a pair of young industrialists' wives, both inquisitive. This evening he was giving them a peek at the world of artists who were just beginning to get talked about. They stayed on their guard. He nodded towards Victor and said to them: "That's him."

"I'll introduce you to them," Harold said to Pierre, who was not interested.

"I'd like to hear your songs from the other evening again," Pierre said to Alice.

"Come to lunch the day after tomorrow. It'll be Sabine and you."

Harold offered Pierre a lift in his car. Pierre accepted. Harold had his chauffeur drop him off at a smart club and asked Pierre to accompany his lady friends to their doors.

Pierre was on his own, sitting between the two of them. Time for a bit of small-talk.

The blonde was what the Germans call a sleepy bunny. The brunette was a valkyrie.

The blonde said: "Which one of us do you like best?"

"I don't know either of you yet," said Pierre. "And besides, what difference does it make?"

"Let's not waste any time. Which of us would you prefer to talk with tonight?"

"Come on now," said the brunette.

"You then," said Pierre thinking of Alice.

They dropped off the blonde at her door. He asked the brunette if they could carry on driving a little longer.

"I at least owe Harold that much," he said to himself. "And then he'll be more likely to tell me all about his love affairs."

Pierre might have warmed to her more if it hadn't been for Alice. She said that artists got on her nerves. She told him her blonde friend had a crush on Harold, that both their husbands had started off with very little and had joined forces to start a business together, but didn't have a spare moment for their wives, and this in the long run was spoiling their lives. Harold was showing them what life was really about. That was why he'd brought them along this evening to François's. They'd been surprised that it hadn't been nearly as much fun as they'd expected, and by the plainness of the *décor*. The only two real men were Harold and Cravan. Victor seemed interesting, but had poor manners playing chess at a party. They wouldn't go back there again.

Before lunch, Alice sang. Pierre and Sabine were quite transported. She was going to make a record of these three songs.

Over lunch they talked about Victor and about Patricia. Pierre thought that Sabine, who was divorced, had perhaps been in love with Victor and that they were still friends. Alice and Sabine were concerned that Patricia and her mother were still at war, that her allowance had been cut off and also about her impulsive behaviour. There was no future in her love for Victor, but the fondness she felt for Pierre might keep her safe for the time being. She had plenty of talent with her fabrics, her drawings, her theatre-work and her poems.

XI

Alice invited Patricia and Pierre to drive out to Boston with her, taking the scenic route.

They left early in the morning. The three of them sat in the back, with Alice in the middle, and the chauffeur drove at a gentle pace.

Here was the majestic exit from New York, the long metallic bridge, the take-off. They talked about nothing and about everything. They felt good together.

Patricia opened the briefcase she always had with her and took out her most recent self-portrait, in water-colours and wax. Here and there was a billow of dainty lacework, and fixed to her belly, a tiny nickel-plated padlock.

"Where is the key?" asked Alice.

"Lost," Patricia said simply.

The expression on her face, in the portrait, confirmed the remark. The whole thing was self-critical in a thoroughly good-humoured way. Alice and Pierre laughed.

Patricia took another one out. "This is me and my twelve children," she said, "I painted it after the big party at Alice's."

In the centre, seated in a garden, was a lactating Patricia, all innocent with vacant eyes, breast-feeding her youngest. Around her were eleven other children, aged from two to thirteen, playing on the grass, in the sand, in the water, each one busy with something different. The eldest girl was reading. It was done with feather-light pen- and brush-work, only the essential lines. An unobtrusive number beside each child marked them in order of age.

"That's for finding the fathers. The list is on the back, but try and guess first. You can check afterwards. Let's see if the little ones resemble them."

Alice and Pierre looked, hesitated, and worked out eight of them. Three of the children were Victor's, then one each fathered by Pierre, Gontran, François, Cravan, Harold, Sigismond, one by her gymnastics instructor and one by an actor she'd performed with. They gasped in surprise.

"There are two fathers you won't know," said Patricia (she pointed at the two babies and named their fathers), "and one who might be a surprise to you."

They singled the child out, it was the smallest one, all thin and pink. They examined it for a long time. In the end Pierre said: "He looks like Alice when she's singing."

"That's right, well done. He's Alice's."

"Patricia," said Alice, "this is the funniest, most moving work you have done.

"It touches me like a drawing by Rembrandt. There isn't a single line beyond what's needed. You were inspired when you did this. How long did it take?"

"Three hours maybe. It was easy. I pictured my life and domestic situation with each of the fathers."

Alice asked Pierre if he had any news about the dancers with the rats, that Patricia had told her about. He hadn't.

"But there has been some drama in the house," said Pierre.

"An old, deaf Swedish man has been living in the basement there. We've helped each other out a bit, he's a joiner, and I've kept notes of his customers' orders when he wasn't in.

"One night when it was really freezing and the radiator was almost no use at all he stuck me in front of a big fire he'd made with some old packing-cases and gave me a cup of coffee. I went and got some chocolate wafers Patricia had given me and we ate them, the whole lot, watching the fire and not saying a word, because he's deaf.

"The next day I saw him go past with an old woman, kind-looking and

respectable, dressed in black. Later on I heard the landlord shouting, trying in vain to make himself heard:

"'You've had a lady here after hours. You'll get us closed down by the police.'

"The Swedish man didn't understand. The landlord wrote on a piece of paper: *She is not a lady,*[25] and gave him the note.

"The old Swedish fellow punched the landlord, who hit him back. Now he's been evicted and I don't even have an address for him."

"How sad," said Alice.

"Very," said Patricia.

They followed an old Indian track through the hills where they saw a maple-sugar factory. They had a lazy lunch in a guesthouse.

They reached Boston at nightfall.

Alice had reserved a suite in a splendid hotel, two double-rooms with a connecting lounge between them.

The ladies put on evening gowns for dinner. Unforewarned, Pierre only had his black jacket. Patricia and Alice were in top form, each in their own way. All three of them felt happy.

"We're at home now," Alice said as she locked the three doors from their rooms on to the corridor. It was a better version of the box-room.

Pierre had been in bed for a little while when there came a knock at his door.

"Alice sent me to come and sleep with you," said Patricia. "She says there isn't any danger since the key for the padlock is lost and we promise not to look for it tonight."

Patricia was wearing an enormous night-dress as if she were a little girl.

She got straight into the bed and laid Pierre's head upon her shoulder.

They chatted for a while.

"All the same," thought Pierre, "this is so natural, and you can't go back.

25. In English in the original, with a note: *"Ce n'est pas une femme honnête"*.

We snuggle up to talk and to sleep. She'd rather be with Victor but that's not an option.

"In essence she isn't free, and nor am I. But here we are starting to sleep together. She makes everything surprising and fun. Where are we heading? Alice looks after her so nicely."

Patricia had dozed off at last. He could feel her breath on his hand.

He switched off the light.

Breakfast with Alice turned out, thanks to Patricia, like a trip to the circus. She was in fine form, beaming and putting on an act, telling their futures, teasing and making mischief.

Then she put her hair into two tight plaits and was quiet Patricia once again. She placed one of her feet next to Alice's.

"Look," she said. "Mine looks like a potato with five little sausages, this one looks like a swan's. Mine is made of meat, this one is alabaster. I am really not beautiful enough! It's a constant burden to me, and that's why I use my eyes and my voice as much as possible. I have to behave eccentrically to capture people's attention, but it has to be rationed. If I could be beautiful all the time, like Alice, I would never move a muscle. I'm just a clown doing hard labour."

"There was genius when you painted your twelve children," said Pierre.

"And when you put the little padlock in your portrait," said Alice.

"Ah!" said Patricia, "a beautiful statue cannot achieve anything. Wait here, I'll show you an Amazon."

From her briefcase she pulled out a large photo of Alice on her black horse, in a forest somewhere. They looked just like two friends. He was so proud to be her steed, and she content to ride him.

"Lots of women wish they had your eyes, your voice, your dancing, your daring," said Alice.

"Yes," said Pierre.

"I have to keep moving to be beautiful," Patricia said sadly. "Victor laughs at me, and sometimes scolds me. How could he love me?"

"Does he love any woman the way you would want?" said Alice.

"No," said Patricia. "But I'm envious of women who can try even so."

When Patricia was quiet they asked: how long does this last?

"Sometimes the whole day," she said.

She dragged her feet across the thick carpet to make static.

They went to visit a Hindu museum whose curator Patricia knew and to a baseball match, which was something quite new for Pierre.

At dinner Alice said: "You two both have to be back for tomorrow morning. I shall continue northwards. You can take the night train, here are your tickets.

"I've been thinking about the old Swedish fellow. Patricia can't go and visit Pierre in his room any more. Here in this hotel, if the management asks guests to open their doors then they have to do so, and if they are a couple they must show their marriage licence. But Patricia would have time enough to slip into my room. Your box-room in New York is no good though because Patricia isn't registered at the boarding-house. The police can be a bit rough in poorer neighbourhoods and unless you hand over a large sum of money right away your names and photos get published in the papers. It's blackmail and Patricia's father is a well-known figure.

"You think it's unfair? That's just the way it is! So no more Patricia spending the night with Pierre! Do you understand?"

"Yes," said Patricia with alarm.

"Here's a ticket for the two of you for the sleeping-car on tonight's train so you can spend tonight as you did last night. They don't ask to see your papers on trains any more.

"Would you like to make another trip with me in a fortnight's time?"

The return by sleeper train. They unpacked their suitcases as if they were a couple. It felt cosy, you could live there. They moved from one bunk to the other. Oh Alice!

They got ready for bed each in their own area of the compartment, chattering away the whole time. Patricia had put on her boys' pyjamas. How

narrow the beds were! She held on to Pierre so as not to fall out.

They talked about Alice. Was she really happy? It certainly seemed she had everything going for her. She and Gontran didn't really let their feelings show. Perhaps they were in love in their own way? Perhaps they wanted a child, but couldn't have one? They were caring towards each other, but was something not quite right somewhere?

"My God, this bed is narrow. Do you want me to go back to mine? Being with you does make me feel relaxed."

Her voice and unaffectedness touched Pierre. So what if she put her head on his chest? It was only to be expected. And if he kissed one of those big eyes? No. Danger that way. All her curves converged on the little padlock.

Very late on, Patricia fell asleep quite suddenly, Pierre soon after. They stayed together like that for the rest of the night, woke up restored and were surprised when they found themselves at the station going their separate ways.

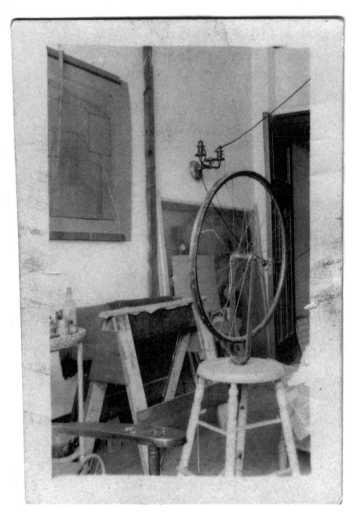

Photograph of Duchamp's studio by Roché
(see also caption on p.90).

(start of the 2nd notebook)

7 *September 1958*

This whole novel *project, with its good parts,* lacks unity. *It moves from sensitive psychological novel (Alice and Geneviève) to the* Surrealist *style — the things Totor*[26] *and François say and do, the description of his room and Totor's Glass.*

It may be too tiring *to* rewrite *it. I'd be better off taking less wide-ranging subjects, in depth, for a purer, more disembodied contemplation, less anecdotal: for example, to have a go at "*The most beloved woman in the world*", Geneviève.*

26. Diminutive of "Victor". [Trans.]

(unpaginated, start of the 2nd notebook, pages about Victor)

Victor. The Glass.
Chess.
Talk with Patricia about Victor's principles.
Studio: Paris and New York.
New Yorker *article — Jouffroy.*[27]
Television Film.
His ideals and how he is seen by the public.
Mary: "He has insisted I be unfaithful," a friend *of Victor.*
Prophet…
*Belief that we use our time and energy badly, that out-of-date complications,
endless wastefulness and* jealousy must be abolished — *the blind and stifling race
for money:* Talk with Patricia.

Sentimental capitalism: we need a kind of sentimental "Communism" — Do we
deserve exclusivity? Is it good for both? — *In certain cases* yes *when natural.*
— *In others* no. — *In any case take care to be* frank. — *Myths to destroy:
"Dissimulation is useful", "Lying can be a kindness".* No. — *What can we hope for?*
— A new code of love. — Devise a new set of ten commandments.

27. Presumably C. Baekeland and Geoffrey T. Hellman, "Marcel Duchamp", "The Talk of the
Town", *The New Yorker*, 6 April 1957, p.25. Alain Jouffroy conducted various interviews with
Duchamp. [Ed.]

Thou shalt stifle jealousy in thy heart completely.
Thou shalt not hope to possess in thy spirit loyally.
Thou shalt always be generous in deed and consentingly.
Thou shalt avoid lying like the plague simply.
(Thou shalt lavish tenderness following thy heart directly).
Thou shalt keep half of thy time for imagination only.
Thou shalt explain thy point of view above all clearly.
Thou shalt guard and give thy freedom equally.
Thou shalt practise integrity with frankness, for lovers the first duty.
Thou shalt tend to thy solitude, as thy needs require faithfully.
Thou shalt have no little children to perpetuate thee heavily.
Thou shalt choose thy way forward and follow it strictly.
(That changes everything...)[28]
Thou shalt shun all virgins, to seduce them would be shabby.
Thou shalt not acquire habits which may kill off love surely.
Thou shalt neither promise nor ask for faithfulness equally.
Thou shalt spend time in meditation and solitude daily.
Thou shalt safeguard thy time and that of others wisely.
Thou shalt ensure that thy work is for thyself alone piously.

Crossed-out passage:

Victor: One must not trample — *one must* have a taste for too little — *one must choose beforehand* what one wants — *I do* not *want* to have children — *I do not want* to seduce a virgin — *I do* not *want* to get tied down — *I do* not *want* routine — *I want to be different things* — *I want to be* alone *with myself more than* one day in two — *I have to reflect.*

28. Comment inserted *a posteriori.*

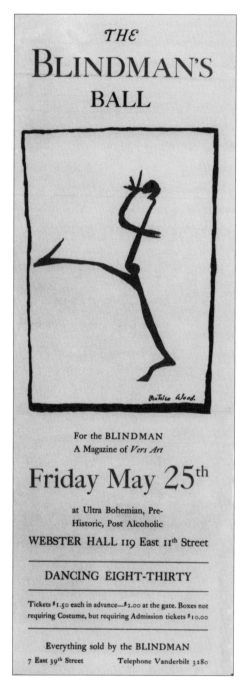

Left: Beatrice Wood's poster for The Blindman's Ball. Above: Beatrice as a moujik, performing a Russian dance, 1917.

XII

Webster Hall

Plans were made for an avant-garde ball. With a few red lines Patricia drew an inspired poster: a red skeletal ascetic dancing away madly.

She opened the ball at Webster Hall dressed as a moujik, with a Russian peasant's bundle of firewood, arms folded, knees bent, doughtily pitching her little boots before her. Her smile and wide-eyed craftiness brought her an ovation.

Alice, Gontran, François, Victor and the general staff of rebel artists filled the box in the middle of the dress circle, from which a long sloping pole protruded at forty-five degrees to suspend a cluster of flags right over the centre of the room.

Everyone was in high spirits. At midnight, Victor, having had a few cocktails too many, decided to detach himself from the conversation and clamber out along this slippery pole. People tried to dissuade him but he got angry, straddled the balcony and struck out. Patricia had to let go of his foot.

"He's going up into his ivory tower," said François.

He was wearing a capacious domino cloak which billowed out around him; he looked like a ladybird on a thick twig.

People were afraid he might fall on the dancers but his movements were steady and soon he became part of the *décor*. He stopped from time to time, and people forgot about him.

"You see," Patricia said to Pierre, "he is agile, *our* Victor. He won't fall."

The final few metres were hard going. When he at last reached the flags everyone applauded. He thanked them with a sweep of his pink paper cap.

The descent was swift. Victor had enjoyed himself.

The ball was a success.

At the door Victor left with Winifred, a young widow he was comforting in his way.

In a sporty mood that day, he practised some balancing tricks with her on the white line painted on the edge of the platform of the Elevated. People took them for drunks.

Pierre and Patricia watched them from the opposite platform.

She wasn't envious of Winifred. "She's sweet, but she's not the sort of woman who could keep him for good," she said. "No one can. He repairs them all. Especially me."

[*Victor and Winifred*]²⁹

He calls Pierre into his room. A statue beside him under a sheet.

He removes the sheet. It's Winifred. "She is leaving for the South. Her brother is coming to fetch her. Could you take her to the station for him and hand her over?

"She has grown too accustomed to New York, she's going to miss life here, but it can't go on."

Winifred. *"Yes, Victor, you have comforted me."*

"Those who die young," he says, "are loved by the Gods."

"I've grown used to being with him. I was having a bit of a breakdown. He says that you'll help me understand."

Pierre at the station: "He needs women. He doesn't need a wife. Nor children. He has to be alone, he's a loner, a ponderer, a thinker. He's a preacher in his own way. He's working towards a new morality."

"He insists I should not be faithful to him."

"The only thing that links you to him is your cure. He hasn't said a single word to you that binds him. He wants you to find a man who'll be yours. He is not that man. *He has performed a miracle.* He neither can nor wants to continue it. You're a car that's been repaired. *Go now. Make way.* One does not marry the Pope."

29. This fragment has been crossed out in the second notebook. The author had, however, underlined some of the phrases so emphatically that it seemed best to reproduce it here.

XIII

Cravan's Lecture

"Why are so many of the smart set interested in this lecture of Cravan's?" wondered Patricia.

Cravan was going to tell the story of his life as a boxer and a poet.

Victor and his friends were there.

In Spain Cravan had challenged the world champion Jack Johnson, another giant, who slaughtered him. At the entrance to the Salon des Indépendants in Paris, Cravan himself had sold his magazine *Maintenant...* in which he demanded that a famous female painter should be publicly spanked.

Cravan was late. People were waiting for him impatiently. Fortunately there was a long bar at the side of the room and everyone stood there drinking.

Every five minutes the telephone rang and a voice announced, in a measured crescendo, that there'd been a traffic jam, or a tyre had punctured, ringing off with: "Do not worry! *He* is coming!"

At last he turned up, like a hunted lion, dishevelled and red in the face, collar undone, sure of himself, and drunk.

He sat down at the little table on the dais, took a sip from a glass of water, pulled a face and began with some lofty phrases.

Suddenly he declared in a faint, changed voice that the heat was intolerable and that in such conditions he could only give his lecture naked. He started undressing, determined to go the whole way.

He was already down to his trousers. What was going to happen?

Then the police arrived, called in by a prudish member of the audience. They got him back into his clothes by force, handcuffed him and led him away.

The let-down was enormous. Had it been worth all the trouble for something so short? Some people were angry, others thought it rather good. "With these forces of nature one must really expect anything," a little lady remarked.

That night, after all the cocktails, Victor, who had stayed behind after the rest had left, for the first time thought he felt a certain bitterness directed at him and his friends. In the doorway, in the fresh air, he staggered uncontrollably.

Pierre came up and put his arm around him to support him. He was heavy. They zigzagged towards a taxi.

Patricia pursed her lips.

"These zigzags are too much," Victor declared. "I'll step out of their way."

And, in contrast to Jack London, Edgar Allan Poe and Modigliani, he brought a halt to this expansiveness which had begun so pleasantly.

"As for me," said François, "I'm not drinking any more. But it was good while it lasted."

XIV

Patricia had a French-speaking rôle at the Jacques Copeau theatre for a few days. Pierre went along to see her and enjoyed her performance.

Gertrude and Pierre translated a long document in German together.

This took them two Sundays, which Pierre spent at Gertrude's place. She had a tendency to mix a little flirting in with their hours of intense work, as Patricia had suspected.

Those two Sundays Pierre didn't see Patricia. It surprised him how put out about it she was.

Gertrude was a friend of Isadora Duncan's, who was depressed, despite having her adopted daughters with her.

"I'll take you to dinner at a place outside town," Gertrude said to Pierre. "Isadora will be there. It's all a plot."

The meal was pleasant, with its high points and lows. Isadora and Pierre found they had friends in common.

At midnight the hostess asked if they would go and have a look upstairs. Up they went, then a key turned and a voice cried out: "This is the plot!"

They were locked in.

Their surroundings amounted to a lounge with a miniature bar and two bedrooms, with big beds.

"This must be one of Gertrude's ideas," said Isadora. "She knows how I worry and is hoping you'll take my mind off things. We've got till tomorrow."

She told him the story of her daughters, how she had adopted them and how she wished to see them married — at sixteen it was time — and what

sort of husband she had in mind for each. Her manner was by turns practical and fanciful.

Pierre was interested in her dancing, which he had seen in Paris. She was candid, sometimes almost brutal.

They weren't attracted to each other. All told they scarcely agreed about anything, although they did find that amusing in itself.

She talked about Victor and about François, who both intrigued her, and about their paintings which she found amazing.

They talked until first light and then went to bed, each on their own.

Had Gertrude made other plans for them? There was no question of that.

The day after next, Pierre was woken by a phone call from Isadora saying: "I have an artwork to show you. Would you come at midday?"

Pierre entered a large studio with long wall-hangings and an inordinately low settee. Isadora looked dazzling.

She put a finger to her lips, took Pierre's hand and led him, on tiptoe, towards a large cabinet which she opened, saying: "Here it is!"

Inside was François, seated upon a box in front of a tiny table, wearing his Napoleonic expression and drinking hot chocolate. His quick eyes lit up.

"Isadora," he said, "has hidden me in here, and without telling me why. I was expecting a duel at the very least."

He asked if they'd like some of his chocolate.

XV

The phone rang early. Drowsily Pierre jumped out of bed and took it off the hook.

He felt an extraordinary sense of well-being. He had lain down on his back, in the grass, with a racecourse of green grass before his eyes, bathed in sunlight, and he was waiting for the horses. He could hear Alice's voice. He blinked and understood. He had passed out, falling over backwards, and the underside of the phone, covered in green baize, struck by the rising sun and right beside his eye, was the racecourse. He'd thought he had been sleeping on the grass but Alice's voice calmly continued the sentence she had begun and he was still holding the receiver. She was inviting him and Patricia to a Toscanini concert and was congratulating him on his new flat.[30] Her rich voice mingled with the racecourse and the perfect sense of well-being. He said yes. She hung up.

He tried moving. Nothing broken. His head had only glanced the foot of the bed.

He had been working too hard. He needed to take some time off with Alice and Patricia.

30. Roché had just left his "cellar" for a two-room apartment on the first floor of the same building.

XVI

The Heat-wave

It was July. An immense, record-breaking heat beat down on New York. For the first few days it had still felt relatively cool in the evening but when the steel frames of the buildings got really hot everyone who could leave New York did so. The public fountains were full of naked children. Above his apartment, as a third outpost, he rented a large studio with a bathroom where they took baths every half hour quite chastely. The heat increased. Patricia could take it; Pierre had stopped eating. He did without food for five days. They felt like they were in the Tropics.

XVII

Victor's Room

While he was away, Victor asked them to stay for twenty-four hours in his enormous studio-room to take receipt of a delivery. He knew how much they wanted to see the place.

Stretched out near the door was an extensible travelling sculpture made of different-coloured rubber.[31] Coat-hooks were nailed to the floor.[32] A bicycle wheel and its fork and a large snow-shovel served as artworks. There were gigantic sheets of glass supported on trestles. Some parts were overlaid with metal shapes, cut out, painted with red lead and stuck to the Glass with a transparent varnish. This was: *"The Bride Stripped Bare by her Bachelors".*[33] Some parts were clear, others coated with layers of dust of varying thickness.

A label said: "Dust breeding. Be careful".

On the wall a painting with *trompe-l'œil* rips held together with *real* safety-pins.[34] And so on in the same vein…

It was Victor's famous room! Patricia was in heaven. For her this was a pilgrimage. She understood everything, more quickly than Pierre. She had a bath in Victor's bath-tub while reciting his maxims: "Shave in the bath with

31. The *Sculpture de Voyage* (Sculpture for Travelling), usually dated to 1918.

32. *Trébuchet* (Trap, 1917).

33. Roché consistently omits the final word (after a comma) of this title, *"même"*, "Even". [Ed.]

34. *Tu m'…*, also from 1918. [Commissioned for Katherine Dreier's library, this piece was made by Duchamp with some reluctance, hence its name, since the missing word indicated by the ellipsis is presumed to be that spoken by Patricia earlier (see p.43, note 11). Ed.]

eyes closed. Check the smoothness with your fingers. No mirror."

They found a few of these thoughts written out.

They slept quietly in Victor's bed. Patricia found things of his all round the place. He had done them a favour in lending them his room. No one ever came here while he was away; the cleaner came by once a week, overseen by Victor who protected his dust-breedings, his toys and the things he kept for ideas.

On the walls were large vertical chess-boards on which he was playing correspondence games with masters in far-off places.

Pages 74, 88, 91-2: photographs by Roché of Duchamp's studio at 33 West 67th st. in 1917.

Page 88: although taken by Roché, this double-exposure shows him apparently asleep in the studio, so the second exposure may have been taken by Beatrice Wood. The following readymades can be seen: In Advance of the Broken Arm *(top, 1915); below, to the right:* Hat Rack *(1917); to the left:* Fountain *(1917).*

Page 91, top: on the wall, a correspondence chess-game; to the left: the first readymade, Bicycle Wheel *(original version 1913, but this would be the second version made by Duchamp in 1916 soon after arriving in New York); below: screwed to the floor,* Trap *(1917).*

Page 91, bottom: the two sheets of The Large Glass *(1913 onwards), stacked against the wall.*
Page 92: further views of the studio.

XVIII

Victor's Work

One Saturday afternoon, Pierre was asked to bring some copies of the second magazine, "Wrong-Wrong",[35] round to Victor's. This review was even freer than the first one and was then on its second issue.

He had never seen Victor at work. That day two women were also there, hard at work in silence like a couple of well-behaved children.

One of them, Pate,[36] a sturdy, unremarkable woman but with eyes that were full of common sense and good spirits, was writing patriotic songs in which the word *strong*[37] rhymed with *wrong*; these were coming along nicely.

The other one, Yvette, a small, round, kittenish woman with an oval face who seemed stern and particular though still pleasant, was working on a small glass of her own design using the same technique as Victor.

Victor worked slowly, and as if detached for two hours. That was his shift. With compasses and a ruler he drew a curving line in the form of a snail:[38] he didn't want his taste to intrude, nor any technical skill on the part

35. *Sic*, and a different spelling here from the one before (p.56). Roché is again confusing *Rongwrong* with *The Blind Man*. [Trans.]

36. Presumably "Pat". [Trans.]

37. In English, as is the "*wrong*" following; a marginal note translates each into its French plural and qualifies it, as "*Forts: les Américains*", then "*Mauvais: les Allemands* [the Germans]". Another marginal note (in English) here has: "It is something wrong against something strong." [Trans.]

38. Crossed-out text from a previous version: "… curve in the form of a snail which he managed to produce with a single sweep of his painter's hand, but he didn't want…".

of his hand, he abhorred that, and turned to geometry and mathematics to help him approach an absolute.

And the result was pure.

Victor had spent two years on this Glass; he would never finish it completely.

When Pierre came in he told them an amusing anecdote. There was no reaction from Victor nor the two women. The realisation came to Pierre that he was in a monastery. When Victor was working it was for himself alone, until he had done what he'd set out to do, untouched by any other considerations. He earned his living by other means.

Patricia never got invited to see Victor working. Perhaps she was too excitable.

As he went out into Times Square, Pierre saw a big display-case with a great knot of snakes in it on one side. These were the Germans. On the other side were some defenceless young animals. These were the Allies. America was starting to get involved.

XIX

Patricia and the Glass

Victor had told Pierre: "Under my mattress, at the foot of the bed, you'll find some notes about my Glass. You can look at them, but don't get them out of order."

Standing before the Glass on its trestles Pierre immersed himself in the notes, copying out bits and spending the whole day over it, together with Patricia.

The scraps of paper were all shapes and sizes, in all sorts of colours, and all of them were covered in things he'd written wherever he'd been or when, on the subject of his Glass — it was Victor's dialogue with himself, noted down on torn-off bits of matchbox card and the corners of restaurant serviettes.

"What's the Glass called?" Patricia asked.

"The Bride Stripped Bare by her Bachelors."

"What a title!"

"It's two and a half metres from end to end and is an epic of desire, a fairy-tale and a mechanical ballet.

"It can be washed in the shower, on both sides. Unlike canvases, says Victor, there's no dust on the back. And it will outlast them."

"What's that up there, that fat grey cloud, shaped like a hippopotamus?"

"That's the original mystery, the Cause of Causes, with its Trinity of *empty squares.*"

"And that strange thing, attached to it, a sort of dragonfly or praying mantis, made of organs the way Victor likes to do in his work?"

"That's the *Bride*.

"There's a note about it: 'This is the Bride, apotheosis of virginity, i.e. ignorant desire, blank desire (with a touch of malice).'"

"Yes," she said, "like me."

"'A shiny metal gallows could simulate the Maiden's attachment to her friends and relatives.'

"'The Bride is a motor which transmits its timid power, quite feeble cylinders, in contact with the sparks of her constant life.

"'Far from being in direct contact with the Bride, the desire motor is separated by a water cooler.

"'There is no question of symbolising by a grandiose painting this happy desire... the painting will be an *inventory of the elements* of this blossoming, elements of the sexual life imagined by the Bride desiring.'"

"Yes. Yes. Go on."

"'The Bride accepts this stripping since she supplies the love gasoline to the sparks of this electrical stripping. Moreover, she furthers her complete nudity... by adding the second focus of sparks of the desire-magneto.'"

"It's all Greek to me, I'm no electrician. But I do like it."

"'The Bride, instead of being merely an icicle, warmly rejects (not chastely) the Bachelors' brusque offer.'"

"Yes," she said. "How well he knows us!"

"Here, 'the last state of this nude Bride, before the orgasm which may bring about her fall.'"

"Alas, there's been no fall for me."

"Not alas," said Pierre. "And that will come.

"This baleful bride dangles from the heavens. This other gallows she's holding pointed at the group of Bachelors, down there below her, is a wave transmitter and receiver.

"Let's move on to the Bachelors."

"They are impressive," said Patricia nervously.

"Victor's written: 'The Bachelor Machine has a masonry substructure, a brick base, a solid foundation. It is fat and lubricious.'"

"Tell me their names," said Patricia.

Pierre picked up a sketch Victor had drawn with various numbered references on it: "'Nine malic moulds, red, standing on end, nine uniforms and liveries. The priest, the cuirassier, the policeman (Patricia identified them one by one), the justice of the peace,[39] the bar-boy, the department-store delivery-boy, the undertaker, the flunkey, the station-master.'

"'They are moonstruck by their own complexity.

"'The desire part changes to the state of an internal combustion engine. The emancipated metal sleigh recites the Bachelor Machine's litany-refrains.'"

"He's mad," said Patricia.

"The glider that supports it moves to the right. Then a series of events takes place but Victor makes no further comment on them. Let's have a look."

"The Bachelors' desire takes concrete form and passes through a series of cones which filter it. It drops into the chocolate grinder with Louis XV feet, which mills it."

"Why has it got Louis XV feet?"

"Seek and you shall find… From there it falls to the ground, on the right but, *by its nature*, bounces back up mirrorically, with mounting speed. Each drop is sent back *mirrorically* to the upper part. Each spangle uses its ingenuity (a spangle derby) to jump across the holes in the sieve, but even then succumbs to the pump's sucking action. The Bachelors' vertical gunfire, passing through the screens and the little target, has such force that it perforates the Glass at several points, like buck-shot, not far from the large cloud of Destiny which overhangs everything. The curtain falls."

39. Roché's list differs twice from that in the published version of the "Green Box" (*The Bride Stripped Bare by Her Bachelors, Even*, a typographic version by Richard Hamilton, Lund, Humphries, 1960). The justice of the peace is in place of the gendarme, and the bar-boy for a busboy. The translation of Victor's notes on the *Glass* has here been made to conform as closely as possible with the wording as it appears in the "Green Box". [Trans.]

Pierre read out a few lines on a piece of blotting-paper:

"'Ovariable all night.'

"'A tap that stops running when nobody is listening to it.'

"'Silk stockings… the thing too.'

"'A queen's lines, aching loins.'

"'A five horse-power with its own destabiliser.'

"'Oblong dress for lady out of breath.'

"'Abdominal furs abominable.'"

"Stop, Pierre," said Patricia. "What a mess! Victor is mad."

"Here are some more," said Pierre. "'Use prime words divisible only by themselves and by unity.'

"'I force myself to contradict myself so as to avoid falling in with my taste.'

"'There is no solution because there is no problem.'"

"That one's the loveliest of the lot," said Patricia.

XX

Patricia took Pierre for a camping holiday a little way south for five days, up in the mountains beside a river. The walls of the cabins only went two-thirds of the way up and the top part was made of a see-through metallic material. There was another cabin on either side of theirs.

Avant-garde artists of all ages were staying there and they took quite a shine to Patricia. A council of elders was convened to straighten out what she was up to with this Frenchman she'd brought along. They worked out the following points:

(1) Patricia had a strange relationship with Pierre;

(2) they were in love but not making love. That was such a pity;

(3) there was no danger in leaving them alone together.

They bathed at dawn and shaved in the river, Pierre his beard, Patricia her lower legs. He went looking for fish which Patricia grilled on some small sticks.

One day Alice came down from New York to see them.

Patricia said to her: "I'm going down a couple of dead-ends. I still love Victor just as hopelessly, but Pierre has consoled me and been charming. We don't take ourselves at all seriously, and we don't want to get married. That would only come about for want of something better or to start a civil war with my Mother, and then I would have to leave home for good. It's not that I love Pierre compared to Victor, I love him compared with others. I often send him letters and drawings, but what have I really been able to say to him? I'm going to ask him to give them back."

XXI

They arranged to meet a couple of evenings later at the Public Library before going on to the theatre. They both liked this building, for its structure, its atmosphere and wide staircases, for the drinking-fountains whose little jets of chilled water you could shoot right to the back of your mouth by pressing a button, and the blasts of hot air which dried your hands.

Patricia was a quarter of an hour late. That had never happened before. When it reached half an hour Pierre really began worrying. The idea came to him that she had been put under lock and key by her mother.

After three-quarters of an hour, he moved off. He walked around the Library and there, drooping in front of the façade, saw Patricia asleep on her feet.

"Oh la la!" she said with difficulty.

They told each other what had happened. They had both arrived on time, but had been waiting on different floors, one on the first and the other on the second.

They went to the theatre without stopping to eat, and not in the happiest of moods either.

They invited Alice out for a meal at Child's, a chain restaurant. They had veal and peas, pancakes and yoghurt. Alice was pleased to find that a cheap restaurant could be so clean. They took her to the Jewish neighbourhood, to a café where a man built like a barrel and his wife of a similar cut were singing. Despite their lack of technique it was quite lovely.

"Oh," said Alice, "how I envy them! All that volume of air, that breast-plate of muscles. They were born with so much, whereas I have to work at

everything. They are dolphins in the sea, I'm just a trout in a stream."

"God made both dolphins and trout," said Patricia. "You can't compare the two."

The next day, whilst she and Gontran were moving a heavy painting by Victor, Alice strained a muscle in her back which was made all the worse because she didn't let go. She spent a fortnight in bed.

The specialist and her voice coach both told her she would have to stop singing.

She passed on this news dry-eyed to Patricia and Pierre when they brought her some flowers.

As soon as she was back on her feet she took to the piano. Her talent shone here just as brightly. The record of the three songs never got made.

At last they set off again on the open road, the three of them in the same seats as before.

At nightfall they arrived at a well-wooded park in the midst of which, on a small hill, was a former private house now turned into a residential hotel. At midnight a great mass of storm-clouds gathered. The lightning was relentless. Pierre held Patricia in his arms and together they felt the increasing sense of uneasiness that was soon followed by each electrical discharge. Pierre was enjoying it, but Patricia wasn't. Suddenly she said: "Alice can't stand thunderstorms! Pierre, go upstairs to her, quickly!"

Pierre went up and knocked at the door. A strangled voice replied: "Come in."

There, with all the lights on, in a thin appliqué-lacework dressing-gown, with scrolling designs, was Alice, sitting up in a Dagobert chair with its back turned to the high window. The lightning flashes lit up the edges of the thick curtains. Her face quite drawn, Alice was a pink flamingo no more, she was a grey flamingo now.

Pierre felt how cold her hands and feet were. He picked her up in his arms and put her on the quilted bedspread on the large bed, rolled her up in it like a pancake and carried her across to a big, deep arm-chair into which he sank still holding her. The lightning made a cracking like someone's tooth being

pulled. Alice fainted. Pierre rocked her gently and breathed warmly on her temple. Thoughts swarmed before him, closing in on him. Was she going to die? Inside he felt something like the pushing of a slow childbirth. At last she opened her eyes.

"Alice, I love you," Pierre said, his face lit up.

"Me too, I love you," she said. "I didn't realise it."

"Me neither. It's like that."

"When did it start?"

"From the beginning. From the first day."

"The same with me. Does it count for anything, in this storm?"

"Yes, absolutely."

"Right… absolutely."

She tried to smile.

"Alice, are you happy?"

"No," she said, shaking her head slowly and softly.

"I thought you were happy. This changes everything."

"Patricia… alone downstairs," she said, stressing her words.

"She was the one sent me up here. She's not as frightened as you."

"I, more than fear… Go downstairs to her! You love Patricia."

Pierre went quiet. He had forgotten her.

"No," he said, "I cherish her. That's different."

"Aren't you going to marry Patricia?"

"No. Neither she nor I want that. She loves Victor. There's never been any question of it."

"I thought… And your Parisienne, Geneviève, who Patricia talked to me about, how do you love her?"

"Like I love you."

"Which means?"

"Completely. I feel respect for the pair of you. You're made of the same noble stuff. You know how to act against your own interests, and have an internal clarity which shows through with time. You make no concessions and no justifications… I want to be your shield. I don't want you to suffer

any more, not you nor her, you're neither of you the romantic type. You are just so. You and Geneviève are of the same nature and it melts me."

They fell silent.

"Have you talked about Geneviève like this to Patricia?"

"Not to this extent. I told her she existed, that's all, as a sort of barrier."

"Does this barrier apply to me as well?"

"No. It's done, it's too late. You are the same, you two are as one to me. Up until now Geneviève had hidden you from me but tonight you sprang right up beside her. The Earth has a second moon. I ought *to be frightened.*"

"Me too," she said.

"I feel overwhelmed."

"Me too," she said. "Quickly, run to Patricia."

Pierre found Patricia pacing up and down the room, in her boys' pyjamas.

"You've been a long time. That was good of you," she said. "Was she very frightened?"

"She fainted."

Patricia settled down by his side as if nothing had happened.

He had a dream where she was Little Red Riding Hood. Would he eat her up by mistake? No.

Inside him, Alice was growing, as patient as the root which shatters walls.

Patricia and he lay there quietly together feeling conscious of their situation and because they were bound by Alice's trust. It was strange and precious. And now Pierre had Alice and Geneviève. And he was aware of it almost all the time.

In short, Patricia was ready for battle — but they weren't. Patricia was a little dog he had looked after for a while, who loved a different master but who lived with him.

Unattainable happiness.

Could Alice and Geneviève co-exist within him side by side? We shall see.[40]

40. Author's note in brackets: "Only a different way of looking at love can save him."

XXII

No, Alice wasn't happy with Gontran, not now. Pierre could see that. But she continued to behave impeccably towards him.

At parties on Saturdays and often Sundays too, he could at least see Victor and Patricia again.

Alice gave Pierre a quick, serene look that said: "Is this for real? Yes? All right, then everything's perfect."

She telephoned him: "Patricia's not free this afternoon. Would you like to come to a concert with me?"

It was the first time they had gone out on their own together. Friends asked after Patricia. She was the one now acting as their guardian. They were unassuming in their happiness, intoxicated by their sense of inner freedom. They were in no hurry.

Pierre felt Alice was discreet but fearless. They had told each other those essential three little words. The little lamp burned deep inside her and nobody but he could see it.

She told him about her father who was dead, how for a long time he was her only love, how she would have loved to see the two of them talking together, Pierre and him, in their first house in Holland.

She knew Pierre better than Pierre knew himself, much better than Patricia knew him, but he didn't know her at all. She fascinated him, and sometimes her eyes moved so quickly she could tell him everything without anyone else seeing a thing. She could read him, and he let himself be read. He had nothing to say.

She was a swallow swooping right past and then coming back again to go "coo-coo". Patricia was a funny little screech owl who understood her limits.

The two of them recognised each other's qualities, but had nothing in common.

Alice arranged to meet him at a pretty little chocolate-maker's. He arrived conscientiously early, then got out his newspaper to look at an article he'd written. Alice appeared behind the newspaper.

"Nasty things, newspapers," she said softly. "It's much nicer to see eyes waiting for you."

"You're right," he said, "it is a nasty thing. An occupational reflex, I'm sorry."

He let her paddle their canoe. Whatever she did, she would do it better for the two of them than he would.

One day, as they were leaving a cinema, his trouser pocket tore open and all the silver dimes fell out and scattered on the ground.

"Should I pick them up?" he asked, smiling.

"A gentleman wouldn't do that, nor would he wear trousers with a ripped pocket. You seem to like these little coins more than the bigger ones. They were all warm next to you and now suddenly there they are on the cold ground. You were giving them hospitality. Pick them up."

He did so.

Another day she said: "I have to go and visit my father's factory, half a day's drive from here. He owned the first one outright, but this one has been turned into a company. Gontran doesn't like to go, Patricia has already been, would you like to see it?"

It had been a while since they'd gone for a drive together. This time was well worth the effort and in the car their feet touched. The factory was new and in the middle of nowhere, with two villages that depended on it.

"They're immigrants from Portugal and the Caucasus. They're magnificently healthy and are decent people. They still don't know any English, and some of them still wear their national costumes. Previously there were strict rules and check-ups for lice, but they would always come

back. My father did away with the rules, recognised their right to retain national costume and the lice too. He built a detached maisonette for every family, with a bathroom, and the people with lice worked only outdoors — hard, basic work and less well paid. It was the twilight of the lice.

"We have people teaching English patiently to the immigrants. They get the history of America in fifteen lessons, as vivid as in the movies, with as many questions as they want. We can go and sit in on a class in a few minutes. Then I shall go on alone to the directors' meeting."

Pierre was not at all surprised to see Alice's rôle become perfectly clear in this American hive of industry. He went all round the fine-looking factory with one of the bosses and liked what he saw.

The history of America was amazing for its abridgements.

Pierre got the impression he was witnessing the hurried construction of a life-raft for the white race.

They had lunch in the small engineers' club.

On the road back, Alice said: "If we get married one day, you won't have to earn a living to support me, just yourself, with your writing."

She had said it, and it came out at the right time, at a time when he felt embarrassed by all that Alice owned.

"If we get married one day…," how naturally that had come to her lips. She wasn't bound to Gontran for ever.

It was a passing thought, but one worth thinking about.

Pierre saw Alice again lying flat on the bed the time he rolled her up in the bedspread like a pancake. He didn't want to set her down anywhere.

The storm had put Patricia and Gontran in their rightful places.

"Tell me about Geneviève," Alice said.

"We've known each other for ten years and loved one another in a way

that's been trouble-free and easy-going. We're the same age. She puts dresses together, with me it's books, both things relying on inspiration. We enjoy our work and decided to see each other just one whole day a week, these are our holidays. Every year we take a vacation close to water. Then, after six years, we suddenly wanted to have a baby. But the eugenic doctor we consulted told us our constitutions would combine to produce children that wouldn't be very strong. So we gave up on the idea."

"Is Geneviève really so defenceless then? How can that be?"

"Yes, she doesn't know how to fight, or doesn't want to, so I felt inclined to fight for her. She maintains that we can never be certain of being right and so prefers to run away. At her fashion house she has a privileged position, because she makes dresses that sell, but is kept to the side because she doesn't produce them on a regular basis. A few friends put up some capital for her to start a small business of her own, but she didn't want to. She thinks: 'For us to have a happy life, let's live out of sight.' I nicknamed her 'Moderation' and 'Integrity'. She isn't romantic. She's afraid passion might be too much for her to deal with, and doesn't make any fuss, nor any demands or promises either. She never wants to show off about anything.

"We fell in love almost without realising it, not knowing if it would last. We still don't know; we have our day together every week, except when I'm abroad.

"She told me about her mother, whom she lost when she was four years old. She speaks better than I can write. Until her aunt could come and take her in she was sent to a nursery school for a few weeks, with twenty or so little girls her age. She showed me a photo. When I saw that damaged yet smiling little face I felt I had to look after her. I'd rather I suffered than her. And that's all.

"We don't really understand what love is. Bits of it come out suddenly by accident. That's the way you've become attached to me, Alice."

"I do respect your Geneviève's character, it's what underlies everything. How long will this war last? How many years will you stay here in America?

What if Geneviève came to New York, and we found her some beautiful clients to dress?"

"She doesn't speak any English. She loves her France. She isn't very resourceful, except with her dresses. However, yes, can we try?"

"Where is she?"

"In a pretty house with gardens, in the Auvergne, a long way from the Germans, with an old servant woman and a rather broken-down adopted old father. She writes to me when she feels like it.

"She tells me about the various animals and insects in the house's grounds, the rural locals whose way of talking she likes."

"Would you show me some of her writing?"

Pierre did.

…

"It's strange. Here you are, expressing your affection for a young woman I do not know, and more strongly than anything I feel for my friends. She really interests me. I feel the three of us are a kind apart, without any competitive instinct. Perhaps we lack something? It's noble, but is it practical? Is it real? *Should one vow to do things for others or for oneself?*"

Pierre felt like a set of precision scales but what he was weighing he didn't know: innocence, purity, lack of ambition, existence itself. He felt they were ready to die rather than kill, ready to be happy if that were to happen; but if it didn't happen by itself, never mind.

"You have declared your feelings twice now for both me and Geneviève," Alice said. "It was all as sudden as the storm. On the one hand it stops me getting close to you, because it has put me in company with Geneviève. On the other hand I am gripped by its purity, it has become my reason for living, and after the lightning you are part of that. You have made me your partner. Please, stop there.

"By chance we are, for a moment, in some non-egoistical state, a terrestrial paradise, a freshly blossoming openness. I shouldn't even have noticed.

"Where can it lead? It doesn't lead. It exists.

"I am grateful to you and to Geneviève for having shown me. Didn't you see it yourself? That makes no difference."

...

...

...

XXIII

Alice and Pierre's Visit to Patricia, now a married woman[41]

They went up the steps of the very ordinary building where Patricia had come to live with her husband. Two rooms and a large kitchen, with a minimum of furniture and belongings.

Patricia was lacklustre. She seemed to have got religion and not got used to it. "Auguste, my husband," she said, "had to leave just now. He's sorry not to have seen you. Being an impresario, he gets work at short notice. He treats me fairly and is quite strict, he teaches me to keep the house tidy, not like I was before. He gets upset if it's untidy, it stops him working."

She showed them her saucepans all neatly arranged and her larder. She said: "There's no doubting this won't last for ever, but right now I really need it. I only do things that are useful now, I'm paying for my past. I'm not ruled by my fantasies any more, and that's very refreshing. My agent is trying to find me a rôle in a burlesque film."

Alice and Pierre felt like they were in a cage with a dying bird.

"Her instincts are true," said Alice. "She has given herself a good purging. She's tough and strong, she'll come out of this and find herself intact again."

...
...
...

41. The narrative here is concerned with events a fair-sized leap in time later.

XXIV

The Evening in Montmartre with Victor and Mary

The ball. Mary's splendour. The long cigarette-holder. Victor not dancing. Supper: oysters and grilled black pudding. They are charming, adorable, not only with each other but towards Pierre, the waiter, everyone. How happy they are and how they deserve it! Modest, even...

A year later... (Delaunay party?) Mary and Pierre. Victor is in the USA... Mary feels abandoned... so beautiful and sad... drinks a bit too much, feels torn up... can't stop, fears spending the night on her own... Dawn... Pierre takes her home... she's forgotten her key... Pierre takes her to his place... protest... desire. The big couch... her sweet-smelling shoulder... Pierre kisses her... Mary in his arms a little... Mary lets go a little, talks...: "He's not coming back... I try to be the way he wants; they're indifferent, or almost, men with no tomorrow..." Bedazzled, Pierre moves to take her. "But don't you think," she says, "that, *for the three of us*, it's a little bit sad?" "Yes," says Pierre, "I think that too." "Wouldn't it be better if we didn't sleep together?" "Maybe," says Pierre, "for you in any case..." A tear comes to her eye. Pierre tucks her in and goes and sleeps on his own.

Twenty years later. Mary dying, at home.

"He insisted that I be unfaithful to him, but that wasn't in my nature. He would say: 'We must love, as much as it happens to us, but we mustn't block each other off from the rest of the world...' What he liked best was not when we lived together for months at a time, but when he came and slept with me two nights a week.

"I accepted this for his sake. Not for mine."

XXV

Victor's Advice to Patricia, or another girl

"You must make a choice. Freedom and risk. Or the so-called right path, a different sort of risk, and children. Love makes you. Love affairs, that's love as well. But you have to go your own sweet way, alas. It's easy to take a tumble. A virgin's share of solitude. Unbridled love becomes hollow and black. Too many affairs make you drunk like too many whiskies.

"Seek out quality. Destroy indulgence in yourself and in the other, myths too. Peel back reality. There is always plenty left.

"Love: an ascesis. Its suppression: another ascesis. What should one be? Purely oneself, without mixture, without glue, clean."

"Stay true to yourself in love, don't abscond into the other. A diamond can sleep with an emerald. They wake up as diamond and emerald, not diamond-and-emerald jam.

"Don't live together for long stretches of time. You have to know how to leave each other in order to be able to find each other again.

"Don't eat the other up, nor desire to be eaten, that leads to indigestion."

"Go with the flow of your ancestors, into tomorrow? Give yourself up to having children? We are no longer *disinterested*. That is another vocation, like another hill.

"While talking to you I like to walk my fingers up and down your back, because it is beautiful. Why? What is the connection between the *loan* of your back and me? You can't give me it, even if you want to and I want it. And is your back yours? Love is a bottomless cup.

"*You and me* grows and then wilts. It ripens. One shouldn't say: that is only appearance. One shouldn't rely on it too much either. That's the mystery, like everything. One can't escape it, either by gorging on it or fasting. It will catch up with you. Which of our instincts should we follow? Ration them.

"There is no mystery, because there is no solution. There is no solution because there is no mystery.

"We get carried over a waterfall. Let's forget about it. For the moment I am touching your back. I catch your foot, shall I never go away? I want to go away often, in order to feel I come back often.

"You don't love me, it's a crush. An invention, a ballet, a work of art on your part, a soap bubble. Sleeping together would serve only to amuse us and register each other's existence. Then misunderstandings. End point perhaps. No virgins for me. Pierre seems 'busy', from what you say. He's a bit like a parent. Seek your own path, like everyone. There is a side to you that is like a spoilt child, another like an abandoned child."

Patricia. "You too are a spoilt child! On all sides."

Victor. "But I am always refusing. I refuse you. Who says I haven't wanted you? You have to find your own line."

Patricia. "The story of your Glass?"

Victor. "I made it. You looked at it. I make no comment. That's your business."

(*NEW PLAN*)

Dialogues in Bed

Pierre and Patricia lying together each describe Victor's smile, features and qualities.

Their pyjamas are armour.

The same two talk about Geneviève. Patricia asks questions and Pierre answers. They get emotional about absent friends.

Pierre and Alice lying together (they end up the same way Patricia had suggested) talk about Geneviève... in a different way, more intuitive, less sparkling, more angelic.

Alice's protection, trust and veto (during the first Boston trip) have been a sword between Patricia and Pierre, more so even than *distant* Geneviève and not of the same order.

Geneviève becomes a gentle sword in its scabbard between Alice and Pierre. Patricia offered a certain boldness. "Why not?" *Variants.*

Geneviève and Alice are of the same order...

These dialogues, this structure, can be the real core of the book.

All the love for Geneviève, close and remote, related in detail to these two, on two levels. She wins in the end, Pierre, *the second time, doesn't go back to Alice.*

Pierre, in spite of himself, becomes a specialist in lying chastely with women (apart from Gertrude, who doesn't count, and who Pierre tells Alice

about, who says: "Victor has a lot like that. He tried it with me, like some sort of Eros, the same as with all the other women. But I'm not that type.").

Abnormal fact, the book's basis: *the candour of Pierre and of the Three* (Alice, Geneviève, Victor).

The four or five heroes seek, find and have a *strict moral code of their own.* They demonstrate it, without theory, in the actual details here.

1915

6 June. Marcel Duchamp (MD) departs France for New York aboard the *Rochambeau*. Arrives on the 15th. Walter Pach has arranged for him to stay in the Arensbergs' apartment while they are away.

September. MD in *Vanity Fair*, photograph on p.6 taken by Pach's father.

1916

5 January. Picabia exhibition at Marius de Zayas's recently opened Modern Gallery on Fifth Avenue.

23 April. The world heavyweight boxing champion Jack Johnson fights Arthur Cravan in Barcelona and knocks him out.

June. The Picabias leave New York.

27 September. While visiting the composer Edgar Varèse, in hospital with a broken leg, MD meets Beatrice Wood (BW), who is also visiting him.

October. MD takes a studio in the same building as the Arensbergs' apartment at 33 West 67th st.

23 October. Henri-Pierre Roché (HPR) arrives in New York aboard the *Philadelphia*.

5 December. MD allows BW the use of his studio. MD first meets HPR, introduced by Varèse.

11 December. BW makes her New York stage début at the Garrick Theatre in Manhattan.

1917

5 January. First issue of Picabia's *391* published, in Barcelona.

11 January. HPR records having lunch with MD.

13 January. MD takes BW to the Arensbergs' for the first time. Arrival of Cravan in New York.

29 January. MD meets with the Arensbergs and John Covert to discuss the Independents exhibition. They decide to ask BW to help.

February. The Gleizes return to New York.

Sunday, 25 February. BW taken to HPR's "cellar" by MD and Picabia. Commencement of events related in *Victor* (ch. I).

26 March. The Arts Ball at the Vanderbilt Hotel (ch. V); in the early hours HPR gives MD the nickname "Victor" because he seemed to carry all before him (soon shortened to "Totor" or "Tor"). BW and HPR begin a sexual relationship.

End of March/beginning of April. MD, along with Walter Arensberg and Joseph Stella, purchase the urinal that will become *Fountain*.

April. MD meets Katherine Dreier.

4 April. The Picabias return to New York.

6 April. USA enters the war in Europe.

7-8 April. MD supervises the hanging of the Independents exhibition, HPR and BW correct proofs and send the first number of *The Blind Man* to print.

9 April. The opening of the exhibition is dominated by the *Fountain* affair, and a meeting of the directors votes against its inclusion. The private view is nevertheless celebratory (ch. VI).

10 April. Independents exhibition (to 6 May), *The Blind Man* published.

12 April. The "whole gang" go to the ball for *Rogue*.

18 April. HPR and BW dine together then join MD, Louise Arensberg and Frank Stella at Barnum's circus. After visiting the Picabias, MD and HPR end up at Louise Norton's, where the three of them spend the night together. The legible part of HPR's diary for this date records him having oral sex with Louise and reaching two orgasms, then "helping" MD to achieve one. The three of them repeat the experience on the 21st, this time with the artist Aileen Dresser as well, and fairly frequently thereafter, over the course of the next few months.

19 April. Cravan's lecture, described in chapter XIII.

20 April. Independents Ball, Cravan and Mina Loy first meet.

25 April. MD, HPR and BW dine together, along with Louise Norton, Picabia and Albert Gleizes, to discuss the second issue of *The Blind Man*.

27 April. HPR and BW work on issue two of *The Blind Man*, a.k.a. *B.P.T.* (Beatrice, Pierre, Totor).

29 April. BW makes drawings for the Blindman's Ball poster in MD's studio. He chooses the one they use, and HPR later approves (ch. XII).

3 May. MD, HPR and BW work on *The Blind Man* during the day and dine together in the evening.

4 May. MD, HPR and BW make final corrections at the printers and send the second number of *The Blind Man* to print.

5 May. Publication of *The Blind Man*, 2.

12 May (Saturday). The dinner at the Arensbergs' described in chapter VIII.

22 May. MD, HPR, BW, the Picabias, Arthur Frost and Cravan dine at the Brevoort.

23 May. The chess-game between HPR and Picabia to decide whether *The Blind Man* or *391* would cease publication. Picabia's win means that *The Blind Man* closes after its second issue (ch. IV).

Friday, 25 May. The Blindman's Ball at Webster Hall, described in chapter XII (originally intended to help finance the magazine).

31 May. The *soirée* at the Picabias' described in chapter X.

June. First of three monthly issues of *391* (no. 5) published in New York.

9 June. MD, HPR and BW dine together and then see a Broadway musical.

Saturday, 16 June. The trip to Boston with HPR, BW and Louise Arensberg, described in chapter XI.

21 June. BW discovers that HPR has been unfaithful to her with a friend of hers, Alissa Frank. MD, Picabia and BW go to Coney Island.

2 July (Monday) to 5 July. Episode of the storm described in chapter XXI.

19 July. MD, HPR and Picabia visit Isadora Duncan at Long Beach. While there BW decides to take Gabrielle Picabia's advice to end her relationship with HPR. Since the trip to Coney Island she and MD have had a sexual relationship.

28 July. MD's thirtieth birthday party is organised by the Stettheimer sisters. The portrait by Steichen (p.36) was taken on this occasion.

Late July. Publication of *Rongwrong*.

August. Publication of *391*, no. 7, which notes the result of the HPR/Picabia chess-game. Around this time HPR and Louise Arensberg begin a passionate affair that lasts for about two years (ch. XXII *et passim*). Picabia and Duncan also have an affair at this time (ch. XIV).

20 September. Picabia leaves for Paris. MD, HPR and W. Arensberg dine together.

9 October. MD is obliged by military regulations to take a job as secretary to a French Army captain in New York on a military mission.

10 October. MD and HPR have multi-faceted portraits of themselves taken with mirrors at the Broadway Photo Shop; Picabia, presumably, had had his taken just before leaving for Paris.

<div align="center">1918</div>

8 July. MD finishes *Tu m'...*, his last painting, commissioned by Katherine Dreier (mentioned in ch. XVII).

23 August. MD departs New York for Buenos Aires, "to set up a hygienic system of *pissotières* [public urinals]" according to Picabia in the 8th issue of *391*.

November. Cravan disappears at sea on his way to Buenos Aires.

<div align="center">1920</div>

HPR and Louise Arensberg's visit to BW, now married, in chapter XXIII.

<div align="center">1924</div>

19 May. MD introduces Mary Reynolds to HPR in Paris (ch. XXIV).

<div align="right">End of *Victor*.</div>

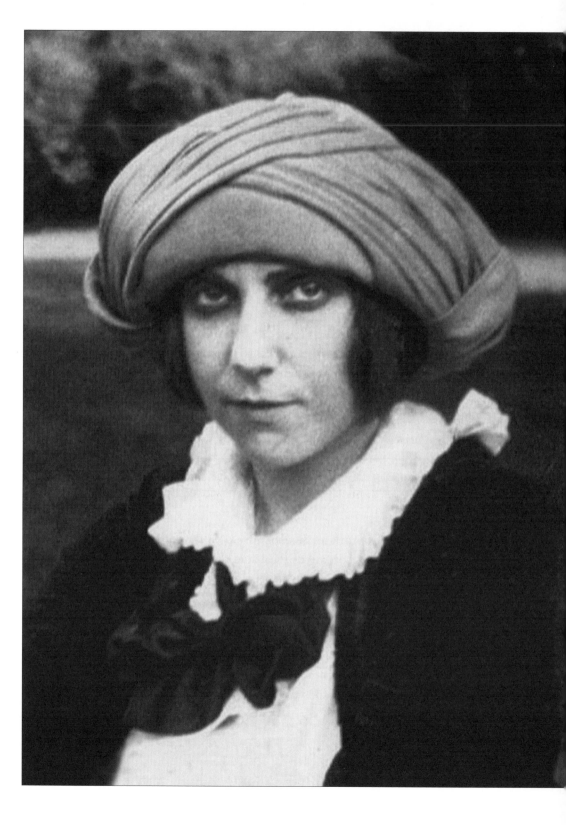

MARCEL DUCHAMP, HENRI-PIERRE ROCHÉ
& BEATRICE WOOD

The Blind Man

Numbers 1 & 2

The official publisher of The Blind Man: *Beatrice Wood in 1917.*

THE BLINDMAN

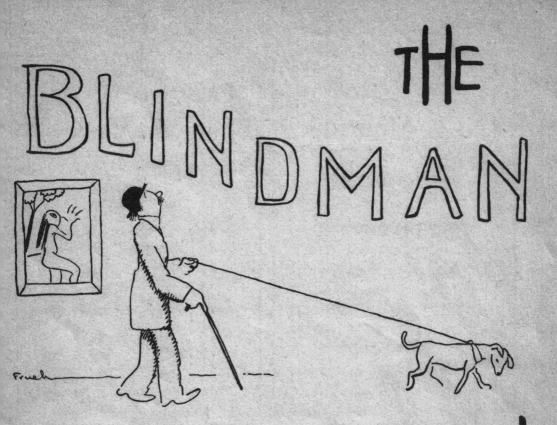

INDEPENDENTS' NUMBER

APRIL - 10TH - 1917 No. 1. PRICE 10 CTS

The second number of The Blind Man will appear as soon
as YOU have sent sufficient material for it.

The Blind Man
33 West 67th Street,
New York.

The Blind Man

I.

The Blind Man celebrates to-day the birth of the Independence of Art in America.

II.

A prominent New Yorker wrote us a few months ago: "You know as well as I do why an Exhibition of Independent Artists is impossible in New York...." And many others were of the same opinion.

The impossible has happened.

The Exhibition is on.

III.

"What is the use of an Exhibition of Independents," said some. "Under present conditions, new talent can easily gain recognition through the picture galleries. They are many and their managers are open-minded."

Let us quote from the programme:

"On one hand we have the frank statement of the established art societies that they cannot exhibit all the deserving work submitted to them because of lack of space. On the other hand such exhibitions as take place at private galleries must, by their nature, be formed from the ranks of artists who are already more or less known; moreover, no one exhibition at present gives an idea of contemporary American art in its ensemble, or permits comparison of the various directions it is taking, but shows only the work of one man or a homogeneous group of men. The great need, then, is for an exhibition, to be held at a given period each year, where artists of all schools can exhibit together—certain that whatever they send will be hung and that all will have an equal opportunity. For the public, this exhibition will make it possible to form an idea of the state of contemporary art...."

"Ingres said, over sixty years, ago: 'A jury, whatever be the means adopted for its formation, will always work badly. The need of our time is for unlimited admission.... I consider unjust and immoral any restriction tending to prevent a man from living from the product of his work.'

"The 'no jury' system, then, ensures a chance to exhibit to artists of every school, and, as a matter of fact, every school is represented at this salon, from the most conservative to the most radical."

The spirit of the Indeps will stimulate, shape and provoke new talent.

The hanging of all works in alphabetical order, for the first time in any exhibition, will result in the most unexpected contacts and will incite every one to understand the others.

It is as easy to see a one-man show as to have a chat in a drawing-room—it is generally quite safe.

Entering the chaos of the Indeps is entering a virgin forest, full of surprises and dangers. One is compelled to make a personal choice out of the multitude of paintings which assail one from all sides. It means strengthening your taste through ordeals and temptations; it means finding yourself, and it is a strain.

The hour has come. The big brotherhood is there, men who have felt the strange need of expressing a little of their soul and of their time with paint and brushes upon stretched canvases—madmen!

IV.

New York will catch the Indeps' fever. It will rush to see what its children are painting, to scold them, laugh at them—and laud them.

V.

New York, far ahead in so many ways, yet indifferent to art in the making, is going to learn to think for itself, and no longer accept, mechanically, the art reputations made abroad.

VI.

In Paris, in 1884, other Indeps were born, humble, hated, scoffed at, weak in body but great in spirit.

During many years, thousands of people came merely to laugh at the stupidities, and were very indignant at the exhibited "monstrosities."

There was, above all, Henri Rousseau, an employee of the custom house, a visionary, who had once been to Mexico and ever after persevered in painting from memory what he had seen there. As a boy I could not take my eyes away from his "ridiculous" pictures.

Today I know why; because they were beautiful, and lyrical, and something more than true.

No one laughs at them now, not even practical collectors, for those paintings which were worth from 20 to 100 francs then, are now worth from 2,000 to 5,000 dollars.

VII.

The French Independents have made of Paris the world market for modern painting, their retrospective exhibitions of Seurat, Van Gogh, Cesanne, have imbued the souls of the younger painters with profound truths which have revolutionized the art of the world.

The Independents became the first spring event of Paris—gay, frank, bold, fertile, surpassing itself every year—while the big jury exhibitions became more and more like grandmothers patiently repeating themselves.

Says the pamphlet:

"The Independents have done more for the advance of French art than any other institution of its period. A considerable number of the most prominent artists of the present generation and the preceding one established their reputations at its annual exhibitions. They have more members, sell more works and are on a firmer financial basis than any other of the four great salons."

VIII.

A principle, which reveals itself fully ripe and at the right time, is invincible. From today we will consider the annual exhibition of the Indeps as one of the features of the season.

IX.

Many of New York's picture dealers give applause to the Indeps, while they really might be expected to oppose them. They realize the need of the public and the artists educating each other.

X.

The Blind Man will be the link between the pictures and the public—and even between the painters themselves.

He will give voice to the enlightening opinions that may spring up, and make them known to all, as impartially as he can, whatever be their tendencies, as long as they are interesting.

He will give to lovers of art the pleasure of thinking aloud and hearing others do likewise.

He will give to those who want to understand the explanations of those who think they understand.

XI.

The Blind Man's procedure shall be that of referendum.

He will publish the questions and answers sent to him.

He will print what the artists and the public have to say.

He is very keen to receive suggestions and criticisms.

So, don't spare him.

XII.

Here are his intentions:

He will publish reproductions of the most talked-of works.

He will give a chance to the leaders of any "school" to "explain" (provided they speak human).

He will print an annual Indeps for poetry, in a supplement open to all.

He will publish drawings, poems, and stories written and illustrated by children.

XIII.

Questions

1. Which is the work you prefer in the Exhibition? And why?
2. The one you most dislike?

3. The funniest?
4. The most absurd?

Guesses

5. What will be the total number of visitors?
6. The number of pictures sold?
7. The highest price paid for a single picture?
8. The lowest?
9. The total amount of money paid for all the works sold?

XIV

Suggestions

Write about the Indeps, or about any special work in the Exhibition.

10. A dramatic story of less than one hundred words.
11. A comic story of less than one hundred words.
12. A dream story of less than one hundred words.
13. A quatrain, or a limerick.
14. A song (words and music).

XV.

To learn to "see" the new painting is easy. It is even inevitable, if you keep in touch with it. It is something like learning a new language, which seems an impossibility at first. Your eye, lazy at the start, gets curious, then interested, and progresses subconsciously.

In Paris the Blind Man has seen people go to exhibitions of advanced art (even cubist or futurist) with the intention of getting indignant about it, and who spend a couple of hours giving vent to their indignation. But on reaching home they realized that they did not like their old favorite paintings any more. That was the first step of their conversion. A year later he discovered in their home the very pictures which had so annoyed them.

XVI.

Among the "new" artists (as well as among the "old") there are a great many who might as well never have painted at all. But let us remember that among them are the half-dozen or so undiscovered geniuses who will give us the style of the morrow.

XVII.

The Blind Man knows an artist who made a good income painting pictures in the "old" way, and who gladly gave it up and faced poverty to study the "new."

"Cubism," said he, "is at least an open door in the black wall of academism."

XVIII.

If a painter shows you a picture, you can make nothing out of, and calls you a fool, you may resent it.

But if a painter works passionately, patiently, and says, "I am making experiments which may, perhaps, bring nothing for many years," what can we have against him?

XIX.

There are fine collections in New York, there are people who understand modern and ancient painting as well as anywhere else in the world. They are few.

For the average New Yorker art is only a thing of the past.

The Indeps insist that art is a thing of today.

XX.

American artists are not inferior to those of other countries.

So, why are they not recognized here?

Is New York afraid? Does New York not dare to take responsibilities in Art? Where Art is concerned is New York satisfied to be like a provincial town?

What chances have American artists who cannot afford to go abroad?

None.

Is that fair?

"No," says a voice. "But why are they artists? Why not something else? We are a young and a busy nation. We shall pay them well if they are willing to do some useful artistic work connected with our business."

"Your useful artistic work is rotten. You simply want them to serve the public taste instead of leading it."

XXI.

Russia needed a political revolution. America needs an artistic one.

Your "little theatre" movement has come. "291" and "The Soil" have come.

Every American who wishes to be aware of America should read "The Soil."

XXII.

Never say of a man: "He is not sincere." Nobody knows if he is or not. And nobody is absolutely sincere or absolutely insincere.

Rather say: "I do not understand him."

The Blind Man takes it for granted that all are sincere.

XXIII.

May the spirit of Walt Whitman guide the Indeps.

Long live his memory, and long live the Indeps!

HENRI PIERRE ROCHÉ.

Why I Come to the Independents

Frankly I come to the Independents to be amused. I am hoping to see many portraits of beautiful young girls with sunlight on the left, and also many gorgeous pictures of tripled head ladies moving in and thro' purple buildings. I expect to see wheels and one-eyed monstrosities.

I want to see some one stand enraptured before a certain soft bronze, then I want to turn my head and watch the moving shadows on the wall. May be I go to the Indeps more for a sense of superiority than of Art.

After all, the painter for me is the man who says "Damn," and goes ahead. BUT, it is the most expressive word in the English language—delicious, bold and stupid.

Again I am not searching for soul-yearnings—

"Pink Clouds in Gold Autumn."

"Niades Dancing in Silver Moonlight."

The emotions of a jeune fille can be acquired at home. I am out for red blood.

I want to return to the ecstacy and wild imaginings of childhood!

Therefore, I come to be amused, to chuckle softly....

If not,—why the Independents!

To laugh is very serious. Of course, to be able not to laugh is more serious still.

BEATRICE WOOD.

Work of a Picture Hanger

I have dragged pictures across the floor for hours. I have heard hammers for hours, and I have felt icy drafts for hours. And this is the Independents the day before! Bare walls with pale canvass lined at their feet. Occasionally only are the faces to be seen. Once I deliberately turned up a Severini and its warm pink tints seemed to cheer me into promises of what might be. Then the smell of wet glue! Mentally I was not spelling art with a capital A. And the mess of trying to remember the alphabet correctly four hundred times! It was fairly simple till we came to the Schmidts—about eight in all. But we no sooner decided they belonged one place than some one placed them in another, and for an hour every time we moved a picture it turned into a Schmidt.

With a sigh I would drag heavy framed canvases along the floor. When I stopped I would look. If it was all right—"ca va" —and away I would chase for another; if not, well—imagine straining your back over old maids' sentimentalities, or pictures of blue-eyed girls caressing gold fish!

I did not rest long. I did not dare; too many overalls. However, I played about some children's canvases.

But as I left, eyes circled and dizzy, I heard a voice; "Say, that Schmidt—doesn't it look fine!"—and I ran.

B.W.

Dream of a Picture Hanger

I was walking in the Independents along the row of the S's. I tried to walk to the N's, but I fell over and into canvases, and each time my foot broke one, I hid it be-

hind a picture marked Schmidt. I came to a doorway, and the doorway became obstructed with large canvases with heavy gold frames. I began to move them and I felt my back breaking, and each time I looked for the name of the artist I saw Schmidt. It made me so mad I took the whole pack, which I had with such difficulty moved, lightly on my head and began running. I ran in and on and over walls. Once I jumped into a picture and sat still, looking like a Chinese god while men passed. I am worth $800 dollars, I thought and I laughed. And I was a piece of soap with nails in my back stuck on a canvas. A big flood came and swamped all the first floor, and the canvases began whirling on the ground . . . blue arms and green legs floated past, and I said to myself: those are the art-critics.

As I was a piece of soap, I, too, must melt, so I flung up my arms wide and I was on a high, high pedestal, looking deep down onto the destruction, and some tiny black man was climbing up to save himself, and as he reached my wing I bellowed, "Who are you," and he answered, "I am— but the rush of the waters drowned his voice, and I woke up. B. W.

In . . . Formation

I do not suppose the Independents "will educate the public"—the only trouble with the public is education.

The Artist is uneducated, is seeing IT for the first time; he can never see the same thing twice.

Education is the putting of spectacles on wholesome eyes. The public does not naturally care about these spectacles, the cause of its quarrels with art. *The Public* likes to be jolly; *The Artist* is jolly and quite irresponsible. Art is *The Divine Joke,* and any *Public,* and any *Artist* can see a nice, easy, simple joke, such as the sun; but only artists and serious critics can look at a grayish stickiness on smooth canvas.

Education in recognizing something that has been seen before demands an art that is only acknowledgable by way of diluted comparisons . . . it is significant that the demand is half-hearted.

"Let us forget," is the cry of the educator; "the democratically simple beginnings of an art,"—so that we may talk of those things that have only middle and no end, and together wallow in gray stickiness.

The Public knows better than this, knowing such values as the under-inner curve of women's footgear, one factor of the art of our epoch . . . it is unconcerned with curved Faun's legs and maline twirled scarves of artistic imagining; or with allegories of Life with thorn-skewered eyes . . . it knew before the Futurists that Life is a jolly noise and a rush and sequence of ample reactions.

The Artist then says to *The Public,* "Poor pal; what has happened to you? . . . We were born so similar—and *now* look!" But the Public will not look; that is, look at *The Artist*—it has unnaturally acquired prejudice.

So *The Public* and *The Artist* can meet at every point except the—for *The Artist*— vital one, that of pure uneducated *seeing.* They like the same drinks, can fight in the same trenches, pretend to the same women; but never see the same thing *ONCE.*

You might, at least, keep quiet while I am talking.

MINA LOY.

Published by Henri Pierre Roché

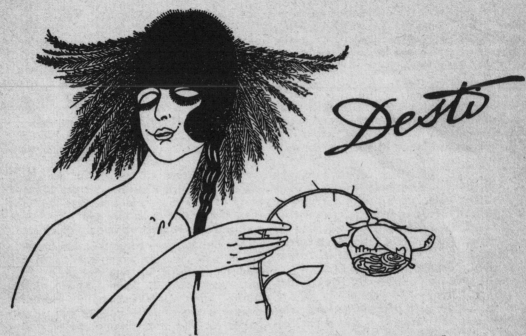

Desti

DESTI CIGARETTE AMBRÉE
AT ALL RESTAURANTS AND HOTELS

IN PREPARATION

P · E · T

P · B · T

THE BLIND MAN

33 WEST 67th STREET, NEW YORK

BROYEUSE DE CHOCOLAT Marcel Duchamp

MAY, 1917 No. 2 **Price 15 Cents**

The Blind Man's Ball

EVERY reader of this magazine is invited to the BLIND MAN'S BALL, a new-fashioned hop, skip, and jump, to be held on

Friday, May 25th

at Prehistoric, ultra-Bohemian Webster Hall. The Ball is given for THE BLIND MAN, a magazine of *Vers Art*.

Axioms du Bal

The dance will not end till the dawn. The Blind Man must see the sun.

Romantic rags are requested. There is a difference between a tuxedo and a Turk and guests not in costume must sit in bought-and-paid-for boxes.

Continuous Syncopations

Tickets, in advance, are $1.50 each; boxes, not including admission, $10, and may be obtained ONLY from

THE BLIND MAN'S BALL

61 Washington Square **Telephone, Spring 5827**

All tickets at the door, $2

Eyes

My god †

what eyes

Eyes on the

Half shell

Robert Carlton Brown.

A RESOLUTION MADE AT BRONX PARK

Robert Carlton Brown

I'M GOING TO GET
A GREAT BIG
FEATHER-BED
OF A PELICAN
AND KEEP HIM
IN THE HOUSE
TO CATCH THE
FLIES, MOSQUITOES AND MICE,
LAY EGGS FOR ME
TO MAKE OMELETTES OF,
AND BE MY DOWNY COUCH AT NIGHT.

TALE BY ERIK SATIE

I had once a marble staircase which was so beautiful, so beautiful, that I had it stuffed and used only my window for getting in and out.

Elle avait des yeux sans tain
Et pour que ca n'se voie pas
Elle avait mis par-dessus
Des lunettes a verres d'ecaille.

S.T., E.K.

Fountain by R. Mutt

Photograph by Alfred Stieglitz

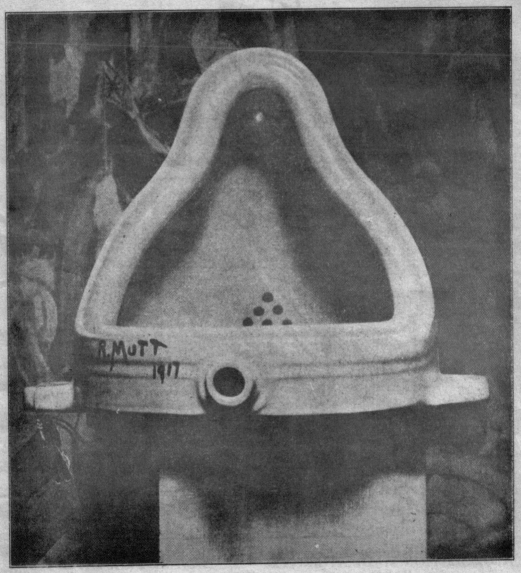

THE EXHIBIT REFUSED BY THE INDEPENDENTS

THE BLIND MAN

The Richard Mutt Case

They say any artist paying six dollars may exhibit.

Mr. Richard Mutt sent in a fountain. Without discussion this article disappeared and never was exhibited.

What were the grounds for refusing Mr. Mutt's fountain:—

1. Some contended it was immoral, vulgar.

2. Others, it was plagiarism, a plain piece of plumbing.

Now Mr. Mutt's fountain is not immoral, that is absurd, no more than a bath tub is immoral. It is a fixture that you see every day in plumbers' show windows.

Whether Mr. Mutt with his own hands made the fountain or not has no importance. He CHOSE it. He took an ordinary article of life, placed it so that its useful significance disappeared under the new title and point of view—created a new thought for that object.

As for plumbing, that is absurd. The only works of art America has given are her plumbing and her bridges.

"Buddha of the Bathroom"

I suppose monkeys hated to lose their tail. Necessary, useful and an ornament, monkey imagination could not stretch to a tailless existence (and frankly, do you see the biological beauty of our loss of them?), yet now that we are used to it, we get on pretty well without them. But evolution is not pleasing to the monkey race; "there is a death in every change" and we monkeys do not love death as we should. We are like those philosophers whom Dante placed in his Inferno with their heads set the wrong way on their shoulders. We walk forward looking backward, each with more of his predecessors' personality than his own. Our eyes are not ours. The ideas that our ancestors have joined together let no man put asunder! In La Dissociation des Idées, Remy de Gourmont, quietly analytic, shows how sacred is the marriage of ideas. At least one charming thing about our human institution is that although a man marry he can never be only a husband. Besides being a money-making device and the one man that one woman can sleep with in legal purity without sin he may even be as well some other woman's very personification of her abstract idea. Sin, while to his employees he is nothing but their "Boss," to his children only their "Father," and to himself certainly something more complex.

But with objects and ideas it is different. Recently we have had a chance to observe their meticulous monogomy.

When the jurors of The Society of Independent Artists fairly rushed to remove the bit of sculpture called the Fountain sent in by Richard Mutt, because the object was irrevocably associated in their atavistic minds with a certain natural function of a secretive sort. Yet to any "innocent" eye

how pleasant is its chaste simplicity of line and color! Someone said, "Like a lovely Buddha"; someone said, "Like the legs of the ladies by Cezanne"; but have they not, those ladies, in their long, round nudity always recalled to your mind the calm curves of decadent plumbers' porcelains?

At least as a touchstone of Art how valuable it might have been! If it be true, as Gertrude Stein says, that pictures that are right stay right, consider, please, on one side of a work of art with excellent references from the Past, the *Fountain,* and on the other almost anyone of the majority of pictures now blushing along the miles of wall in the Grand Central Palace of ART. Do you see what I mean?

Like Mr. Mutt, many of us had quite an exhorbitant notion of the independence of the Independents. It was a sad surprise to learn of a Board of Censors sitting upon the ambiguous question, What is ART?

To those who say that Mr. Mutt's exhibit may be Art, but is it the art of Mr. Mutt since a plumber made it? I reply simply that the *Fountain* was not made by a plumber but by the force of an imagination; and of imagination it has been said, "All men are shocked by it and some overthrown by it." There are those of my intimate acquaintance who pretending to admit the imaginative vigor of Mr. Mutt and his porcelain, slyly quoted to me a story told by Montaigne in his *Force of the Imagination* of a man, whose Latin name I can by no means remember, who so studied the very "essence and motion of folly" as to unsettle his initial judgment forevermore; so that through overmuch wisdom he became a fool. It is a pretty story, but in defense of Mr. Mutt I must in justice point out that our merry Montaigne

is a garruolus and gullible old man, neither safe nor scientific, who on the same subject seriously cites by way of illustration, how by the strength simply of her imagination, a white woman gave birth to a "black-a-moor"! So you see how he is good for nothing but quotation, M. Montaigne.

Then again, there are those who anxiously ask, "Is he serious or is he joking?" Perhaps he is both! Is it not possible? In this connection I think it would be well to remember that the sense of the ridiculous *as well as* "the sense of the tragic increases and declines with sensuousness." It puts it rather up to you. And there is among us to-day a spirit of "blague" arising out of the artist's bitter vision of an over-institutionalized world of stagnant statistics and antique axioms. With a frank creed of immutability the Chinese worshipped their ancestors and dignity took the place of understanding; but we who worship Progress, Speed and Efficiency are like a little dog chasing after his own wagging tail that has dazzled him. Our ancestor-worship is without grace and it is because of our conceited hypocracy that our artists are sometimes sad, and if there is a shade of bitter mockery in some of them it is only there because they know that the joyful spirit of their work is to this age a hidden treasure.

But pardon my praise for, sayeth Nietzsche, "In praise there is more obtrusiveness than in blame"; and so as not to seem officiously sincere or subtly serious, I shall write in above, with a perverse pen, a neutral title that will please none; and as did Remy de Gourmont, that gentle cynic and monkey without a tail, I, too, conclude with the most profound word in language and one which cannot be argued—a pacific Perhaps!

LOUISE NORTON.

FOR RICHARD MUTT

One must say every thing,—
then no one will know.
To know nothing is to say
a great deal.
So many say that they say
nothing,—but these never really send.
For some there is no stopping.
Most stop or get a style.

When they stop they make
a convention.
That is their end.
For the going every thing
has an idea.
The going run right along.
The going just keep going.

C. DEMUTH.

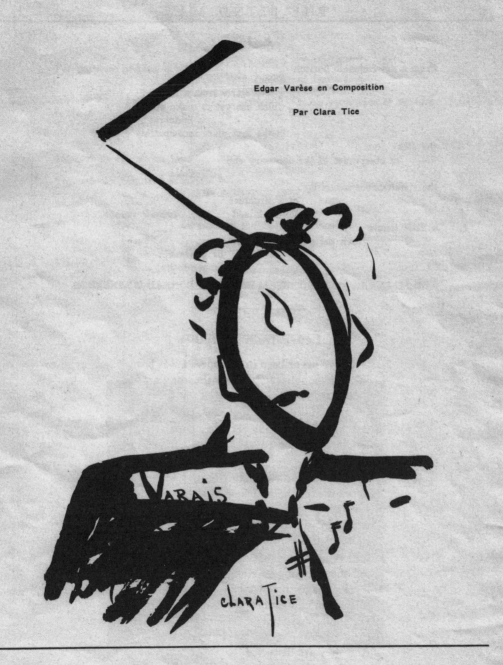

Edgar Varèse en Composition

Par Clara Tice

Recharge, please, recharge
avec la chimie de ta salive
l'accumlateur de mon coeur.

S. T. E. K.

Axiom

From a determinable horizon
 absent
 spectacularly from a midnight
 which has yet to make public
 a midnight
 in the first place incompatibly copied
the other
 in observance of the necessary end
 guarantees
the simultaneous insularity
 of a structure
 self-contained
a little longer
 than the general direction
 of goods opposed
 tangentically.

 WALTER CONRAD ARENSBERG.

Letter from a Mother

I have never been in Europe. I was born in Minneapolis and I am the mother of three children, all gifted, two exhibiting in this exhibition.

I have always felt nervous about artists, but in my modest way I am a believer in democracy.

Therefore as a woman who has done her duty towards the race and experienced life, I make the plea to all other mothers and women of constructive comprehension, that we keep this exhibition sane and beautiful.

It is only by elevating the soul and keeping the eyes of our young ones filled with lovely images that we can expect good results from the generation that will follow.

People without refinement, cubists, futurists, are not artists. For Art is noble. And they are distorted.

Independence is needed, but a line must be drawn somewhere.

In sincere faith I hope for your success.

 Sincerely,
 A MOTHER.

Theorem

For purposes of illusion

 the actual ascent of two waves
 transparent to a basis
 which has a disappearance of its own

is timed

 at the angle of incidence

 to the swing of a suspended
 lens

from which the waves wash

 the protective coloration.

Through the resultant exposure

 to a temporal process

an emotion

 ideally distant

 assumes on the uneven surface

 descending

 as the identity to be demonstrated

the three dimensions

 with which it is incommensurate.

 WALTER CONRAD ARENSBERG.

CONEY ISLAND Joseph Stella

From a friend.

April 12, 1917.

Dear Blind Man:—

Fine for you!

You are, I hope, to be an instrument for the accomplishment of an important and much-needed work in America; namely, the fostering and encouragement of a truly native art. An art which will be at once the result of a highly vitalized age, of a rest-less artistic spirit, and of a sudden realiza-tion,—on the part of our artists—of Amer-ica's high destiny in the future of the world. Such an art must very closely embody the spirit of our time, however morbid, how-ever hurried, however disorganiezd, how-ever nerve-racking that time may be.

A bas,—you should say—with any and every school of art that represents another day, another spirit, another time. No art can live that is not an integral part of its time. Put Botticelli in a studio on Fifth Avenue; put Corot in a garret in Washing-ton Square; put Fragonard in a barn in Harlem, and their work would be worth-less, sterile, of no lasting purpose, or power of evocation; because it would fail abso-lutely to symbolize and synthesize the spirit of our age. Their work would merely be something promoted, not by our life, not by the vitalized forces of our time, but something promoted only by the flat, dead and profitless spirit of a bygone time.

So, if you can help to stimulate and de-velop an American art which shall truly represent our age, even if the age is one of telephones, submarines, aeroplanes, caba-rets, cocktails, taxicabs, divorce courts, wars, tangos, dollar signs; or one of des-perate strivings after new sensations and experiences, you will have done well. The future dwellers upon earth will then be able to look back to our day, and, with truth and conviction say: "Yes, they had an art, back in New York, in the days following the Great War, an art that was a vitalized part of their life; that mirrored accurately their time, with all of its complexities, graces, horrors, pleasures, agonies, uncer-tainties and blessings."

Admiringly yours,

FRANK CROWNINSHIELD.

MEDUSA

Sinister right—dexter left—superior hypocrecy
Spirits without light and Don Quixotes
Arts starboard, red and green port
without vessel.
Why change men into animal foeti.
My tongue becomes a road of snow
Circles are formed around me
In bath robe
Exterior events
Napoleon
Modern ideas
Profound artists reunited in canon
who deceive
Artists of speech
Who have only one hole for mouth and anus
I am the lover of the world
The lover of unknown persons
I am looking for a Sun.

F. PICABIA.
April, 1917.

Pas De Commentaires!
Louis M. Eilshemius.

"Soul....Soul! Your artists haven't got it; for them things are just chair, or table, or stables. Was it Aristotle who said, 'A picture is a silent poem?' — — — — —

"But you are not seeing my pictures **now**... What is a minute, an hour? Ruskin, (have you ever heard of Ruskin?) found it necessary to look at a picture for a steady week.

"I have two thousand pictures—how long do you suppose it would take an **ordinary** artist to paint this one?" asked Louis Eilshemius pointing to 'Maidenhood Confronted By Death'— —. This is the first time she has seen death; observe the effect—**Horror**—! that's quite new—the stormy sky enforces the idea; see how it bursts,— death, that's it, a burst!" We computed that it would take perhaps three weeks to paint such a picture—. "Well it takes me just two hours! I always paint on cardboard, that's new! You can't get such quality on canvas." Wandering round the bountifully endowed studio we found such variety of subject and treatment, as to give us some idea of the scope of this artist's mind. As Rousseau of the French spirit painted in France, does Eilshemius of the American spirit paint in America, with the childlike self-faith of a Blake.

His conceptions are traditional of the simple soul unhampered by a traditional mode of representation. Eilshemius paints women dancing, moonlight and the devil, and it is significant after looking him straight in his unspoiled eye, that his princes of darkness are repeatedly the best tempered, most unsophisticated young devils imaginable, and that his nearest approach to evil is in the symbol of the horn.

Eilshemius has not evolved, he has just grown to scatter seeds hap-hazard but at will to blossom in the amazing variations of his pictures, which, outside every academic or unacademic school, untouched by theory or "ism," survive as the unique art form that has never been exploited by a dealer, **never** been **in fashion**!

His is so virginally the way a picture must be painted by one unsullied by any preconception of how pictures are painted, so direct a presentation of his cerebral vision, that between his idea and the setting forth of his idea, the question of method never intrudes.

The complicated mechanism that obtains in other artists a prolonged psychological engineering of a work of art, is waived; his pictures, if one may say so, are instantaneous photographs of his mind at any given moment of inspiration.

"I am very broad-minded," said Eilshemius, "I like everything that is nice, everything," smiling benignly, "that is **nice** you understand. I can paint anything, anywhere, beautiful pic-

"SUPPLICATION"

tures on your hat or your dress, if you like! — And I only use five colours, any particular five colours? Certainly not. I'm not one of your hocus-pocus painters who have to have certain colours, certain palettes, certain — — —. I paint with my imagination, look at this! Victis—you know what victory is? Pressing the other fellow down!"

Three fine nudes in an evening sky, each with a different coloured ribbon; the one on top, is the one on top! "See that one there 'on the right he's dying; you notice that on his face."

Hopefully inspired by the granite simplicity of the painter's speech I asked him if he ever wrote—"Don't you know who I am—" he gasped?

"Louis M. Eilshemius, M. A. Supreme Protean Marvel of the Ages. The Peer of all who create Painting, Literature and Music."

As I am used to do in reading I found by intuition the finest passages while skimming the volumes handed to me:

"How most are sore misled by pope and priest
To think that God hath arms and feet and eyes—"

"And my weird soul hath felt
The whiffs that waved from forth my heart."

IN LIGHTED SLEEPNESS.

BLIND

WAKING WAKING

DISTANT CENTER CENTER

UP

SLOW TAKING ISLAND-OCEAN SLOW

WATER YESTER CONTACT'S SEAS SHIFTING

TRIANGLE JOYS POINS

INCISOR VISTA YELLOW

FOUNTAIN

WIDE IN ALL

FORTH OVER BACK UPSURGING FACTS HEAVY LIGHTNESS BACK OVER

INSURGING RHYTHM SHOUT EARTH SHOUT ALIVES

ALL HIGH LAY LIE RELAY IN

EVEN OPEN PENE SEPARATE REMARK ENLEVEL LEVEL ALWAYS

TON'SILENT TONS OVER DOUBLE TONNAGE DOUBLE THRU THRU TON AND TON
 AND TON SHIFT

ALL ALL IN IN THIS BODY BALANCE AND RESURGE

LEVEL LEVEL COOL BIG SAD:......IN RUST GOLD DARK DUST HAIR:

DISTANCE

SPREAD NOW NOW, NEW FOREST FRAGRANT FOREST HAIR RESURGING REFORTH

PENET UP

FAR, THRU EYES, AREA

FLOW WATER FEEL DEEP DEEP......IN IN FAR FAR FARTHEST

MOUNTAIN MOUNT KATAHDYN FLUX KATAHDYN MOUNTAIN FLU).....FLOWER

IN IN, THRU EYES, SLEEY SLUMBER HEAVE

To be read beginning with lowest line. Top line last.

Third Dimension;

Portrait Sketch

Charles Duncan

"Free Verse, why I wrote free verse twenty years ago"—?

Yet while Eilshemius exonerates himself from ever having studied the works of any period whatsoever, there is a something Elizabethian about him.

I will end this rummage of a gold-mine with Eilshemius when he is most himself—in the the poems "A Country Child" and "Maggie the Geyser Guide."

"It dwelled, where I would not to live; In a hut, with cracks and holes. But there it played with wicker and mud;

And it tried to lift long poles." "Have you no fear of all those boiling waters?" "Nay, I was 'hatched' right on this steaming earth. The other place cannot be worse!" she ventured, And in our eyes a twinkle suddenly had birth. Thus questioning, she grew more sweet to me, for in her voice Lay mellow dreaminess, that made my heart rejoice.

Anyhow, Duchamp meditating the levelling of all values, witnesses the elimination of Sophistication. **MINA LOY.**

MARIE LAURENCIN

She is shortsighted—nevertheless, no detail of life escapes her.

She is sentimental—yet, she has a very acute sense of irony and of the ridiculous.

She is bourgeoise and respects social conventions but recognizes no other law than her fantasy.

She seems frail and defenseless, but her egotism, unceasingly active, makes her unattackable.

She has remained a playful and dangerous child even if her vision is clear and wise.

She gives herself, reveals herself, opens her life like a book but remains impregnable.

She loves richesse, elegance and luxury and is fond of the realities of order and economy.

She has been little influenced. Perhaps some English painters, whose aristocracy she loves, have left some traces in her work.—She does not recognize esthetic conventions.—She recreates the world to her image. She does not know but herself, does not represent but herself, and even when she copies she does not express but her own imagination.

In her work, she only loves the accomplished effort, being contemptuous of its artistic value. Though she does not attempt to go beyond the conventionalist of representation, her spirit shows all the comprehension of modern art. She invents according to her fantasy and makes her selections according to her profound instinct for harmony and rhythm. To her gift of painting she adds her literary gift which is always felt in her work.—A drawing of hers, scarcely sketched often tells a long story.

She loves her femininity which she exalts and cultivates, finding in it her best sources for her inventiveness.

The seventeen drawings and watercolors exhibited at the Modern Gallery have the charm and subtlety which she always imparts to her work, but to me, three of those drawings especially reveal her personality: "The Little Mule" is an astonishing expression of her literary imagination and of her sense of protection.— The animal has a human expression, the troubled expression of her own eyes—the delicacy of its lines, the elegance of its details, preciously reproduced, evoke the mystical personage of a prince encased in the body of a beast.

"The Lady of the Palms" is an old fashion plate, its complicated architecture charmed her. Her fantasy, her sense of form and harmony transported the old fashion plate into a landscape of palms.

"The two Dancers," by the accuracy and sobriety of its traits, by its ensemble and proportions, give the sensation of a moving rhythm.

It would be odd to see Marie Laurencin in America.
 GABRIELLE BUFFET.

The Supreme intense gluttony
To Cut , my throat.
The utter lust to let
Red Blood roll down
The expectant upturned breasts
Or what better than
The smooth security of
Tightening rope
When mass obeying gravity
Forfeits Life?
Perhaps my head upon the sill
A window
Coming swiftly down
Would link my consciousness
With Queens.
Again a knife

In the grasp of that impenetrable
 blank wall
I Falling
Might lend at last a line
To pure Monotony.
Have I courage to keep on
Beating out my Brains
When Regret should have entered
The First Fist?
To die with flowers? Too soft—
To burn in perfumed oil?
 Too slow—
All forces that are not Mine—
I will, I will Hold my Breath—
...
And Fell asleep
And Dreamed I drowned.
 FRANCES SIMPSON STEVENS.

**Let us droop our heads over each other like lilies
And our bodies remain long.**

ALLEN NORTON

O Marcel - - - otherwise
I Also Have Been to Louise's

I don't like a lady in evening
dress, salting
From here she has black eyes,
no mouth, some - - - -
Will you bring a perfection,
well bring a bottle - - - Two
perfections WELL I want to SEE
it - - - he will know it after-
wards - - - will you bring the
bottle. Really, have I? - -.
Which way? Oh did I? WHEN?
Too much? You are abusing
myself. No, you would not - -.
Did you ask Demuth about it?
Anything you like, would I?
Ough Naow? of course not? Yes
I do. I used to kill myself
with the syphon - - -. You
don't remember that ball. Well
don't do that because I am per-
fectly sober now - - - - that's
the kid he looks like - . It
will probably cost me very much
I have not got money. Did I
say I wanted the bottle all
right - SEE it! Excuse me,
explain it. You don't need any.
I will give you some paper
Mina and keep silent to give
you a rest. Oh! I will give
you some paper all the same.
Very much. He said to me, we
will toss whether you resign or
I resign - - - a very old
French story about 'the English
man must shoot first.' She has
a pencil in her hair - very
impressionistic. You know you
should have some salt on your
hair it's so nice - because?
Nothing - its music. Ah this

is, this is, this is, is IT.
Do not worry about such things
as lighting a match. I give
you my key Clara - HEY - have
some yellow paper. If carried
away If Clara ever returns it.
Well, you did about a week,
after. Here's the salting lady -
I will show her to you - salting
lady. She passed. Do not speak
any more - - - you have to
squeeze it, maid of the - - -.
I used to go every day - -
waitress. I feel ashamed in
front of this girl - she looks
at me from far its wonderful -
its wo - onderFUL¡
Yes, have a drink lady, teaspoon
by teaspoon. No please take
this - Do I eat? You know why I
have one - I do - I do have it -
I want some tongue I will give
you some - but don't do too much
what? Suck it. Well I don't know
how I will get up early to-
morrow I have a lesson at two -
no not with the "bellemere" You
don't know what a wonderful sen-
sation it is - - - - - I have
some preference for some com-
pany where is our waiter -
where is he it sounds it doesn't
he?
Mina are you short-hand?, I
never knew it. I want tongue
sandwich, anyway it keeps me
awake. You know, she comes rid-
ing school fifty sixth street
you know she comes. Lunch
12 o'clock. Well you know it
was. How do you light a cigar-

ette - how do you light a match
Did you, well it is not danger-
ous at all - Did you got it?
Are you an American represen-
tative - I am sorry. You are
Pennsylvania I am Boston. Do
you want some cigarettes - - Did
you put the pronunciation.
Waiter! tongue sandwiches. Do
you want hot milk. Two perfec-
tions she doesn't want anything
- you got it? She can't write
it down anyway - through the
flag oh some cigarettes - waiter
I want some cigarettes for Mina
- this is a wonderful tune Ti
lis li laera Mina I give you
two dollars, it means to me two
dollars - Ti li li laera - - it
is twice I need to shave now.
Demuth you must be careful of
your key she keeps it about a

week every key she gets she
keeps. You speak like Carlo,
well when he wants to imitate
well have a drink! You know
those two girls are crazy about
that man, they mustn't, you must
get him out. I will have a
tongue sandwich - you must suck
it - - - Censorship! Don't let
your flag get wet - - is that
Billy Sunday. One should have
had an additional star Billy
Sunday - There's always a sky
in heaven! - - - that is too
low. My ancestor is tall
people. Don't write, he is going
to leave you for a minute.
Sandwiches - Oh I forgot to
telephone - what shall I say.
Ti li li laere - she said - all
right!

Compiled by Mina Loy

291 Fifth Ave., New York
April 13, 1917.

My dear Blind Man:

You invite comment, suggestions. As I un-
derstand the Independent Society its chief func-
tion is the desire to smash antiquated academic
ideas. This first exhibition is a concrete move
in that direction. Wouldn't it be advisable next
year during the exhibition, to withhold the names
of the makers of all work shown. The names,
if on the canvases, or on the pieces of sculpture,
etc., exhibited could be readily hidden. The
catalogue should contain, in place of the names
of artists, simply numbers, with titles if desired.
On the last day of the Exhibition the names of
the exhibitors could be made public. That is each
number would be publicly identified. A list of
the identified numbers could also be sent to the
purchasers of catalogues. To no one, outside of
the committee itself, should any names be di-
vulged during the exhibition. Not even to those
wishing to purchase. In thus freeing the exhi-
bition of the traditions and superstitions of names

the Society would not be playing into the hands
of dealers and critics, nor even into the hands of
the artists themselves. For the latter are influ-
enced by names quite as much as are public and
critics, not to speak of the dealers who are only
interested in names. Thus each bit of work would
stand on its own merits. As a reality. The pub-
lic would be purchasing its own reality and not
a commercialized and inflated name. Thus the
Society would be dealing a blow to the academy
of commercializing names. The public might
gradually see for itself.

Furthermore I would suggest that in next
year's catalogue addresses of dealers should be
confined to the advertising pages. The Indepen-
dent Exhibition should be run for one thing
only: The independence of the work itself. The
Society has made a definite move in the right
direction, so why not follow it up with still more
definiteness.

NO JURY—NO PRIZES—NO COMMERCIAL
TRICKS.

Alfred Stieglitz.

THE BLIND MAN
Notes and commentary

I, page 1. The front cover, including presumably all the lettering, was drawn by Alfred Frueh. This perhaps explains why it is only here that it is spelled as *The Blindman* in one word (even the address below, that of Duchamp's studio, gives it as *The Blind Man*). Frueh (1880-1968) had studied art in Paris and was given his first exhibition of drawings by Stieglitz in New York in 1912, which is how Duchamp *et al.* would have known him. He became the house theatre caricaturist for *The New Yorker* from its first issue in 1925 until his retirement in 1962.

I, 2, adverts. The Modern Gallery, much patronised by the Arensbergs, was run by Marius de Zayas from 1915-18, when it became the De Zayas Gallery until 1921. Although he had good connections with contemporary and less conventional artists in Europe, his stable of modernists consisted of the more established names listed here, of whom perhaps only the Catalonian sculptor Manolo Hugué and the American Cubist Frank Burty Haviland are now not so well known.

I, 8, back cover, P.E.T. in preparation. This refers to the next issue of *The Blind Man*, in the event surtitled P.B.T., but does not explain what the E is doing here instead of B for Beatrice.

II, I, front cover. P.B.T. = Pierre (Roché), Beatrice and Totor (Duchamp). The *Broyeuse de chocolat (no. 2)* dates from 1914 and was a study for one of the principal elements of Duchamp's *Large Glass*.

II, 3, Robert Carlton Brown (1886-1959). Often known simply as Bob Brown, a rather unjustly neglected American poet, writer and fellow-traveller of modernism. Quite how he had crossed the path of Duchamp at this time is unclear, perhaps through his editorial connection with *The Masses*. Edited by Max Eastman, who was occasionally to be seen at the Arensbergs', this magazine was the chief forum for progressive leftist politics and one of its aims had been to forge links with the artists previously involved with the Armory Show (although Brown and

Eastman fell out over the latter's approach to this). Brown was a prolific author and tireless adventurer, particularly in Central and South America. In Paris in the Twenties he became a part of the expatriate writers' community and published numerous books of poems through his own Roving Eye Press (*Globe-Gliding*, 1930; *Gems*, 1931; *Demonics*, 1931). He was also published by Nancy Cunard's Hours Press, for which his *Words* (1931) featured poems printed so small that a high-powered magnifying glass had to be deployed. Black Sun Press put out his *1450-1950* in 1929, which was composed, in the main, of poems similar to the drawing in *The Blind Man*; as well as including a variant of that

picture-poem, the book also features the autobiographical self-portrait illustrated above, within which the same poem occurs once more, in miniature. (The 1959 reprint of *1450-1950* by the Jargon Society is well worth finding.) After the Wall Street crash Brown returned to the Americas, mainly travelling and writing cookbooks with his wife Cora, the end of prohibition being celebrated by a tome called *Let There be Beer!* His last years were spent running a bookshop in New York.

II, 3, S.T., E.K. These initials are something of a mystery, recurring again on page 7 without the comma. They resemble a compression of "Satie, Erik" and although the first text is a paraphrase of one by Satie from *Enfantines II* (Demets, 1914), the second does not seem to be by him. Satie's own (and much superior) version of the first text is called "Steps of the Grand Staircase", and reads:

It is a grand staircase, very grand.

It has more than a thousand steps, all made of ivory

It is very beautiful.

No one dares to use it for fear of spoiling it.

The King himself has never used it.

To leave his room, he jumps out of the window.

And often he says:

"I love this staircase so much I am going to have it stuffed."

The King is right isn't he?

The French of the second text on page 3 reads:

She had two-way eyes

And so that you couldn't see this

She put on

Tortoise-shell rimmed spectacles

II, 4, the photograph of *Fountain* is by Alfred Stieglitz, taken in his gallery 291. Stieglitz (1864–1946) was the most important figure in the history of photography in the USA between the late 1890s and early 1920s. A major photographer himself, he also founded and edited the leading US magazine devoted to the subject, *Camera Work* (1902-1917), while his gallery showed photography alongside contemporary painting and sculpture from Europe and the USA. However, Stieglitz's modernism was "first generation", akin to Coady's (see Introduction), and Stieglitz himself was well aware that it was now in question.

On 13 April 1917 Beatrice Wood notes in her diary "See Stieglitz about Fountain." The urinal was photographed some time between 13 and 19 April, when Stieglitz wrote to the critic Henry McBride inviting him to 291 to see both the photograph and *Fountain* itself. *Fountain* was subsequently lost, so Stieglitz's photograph remains the *only* accurate record of this object.

II, 5, The Richard Mutt Case. As her memoirs confirm (p.165), this text, usually attributed to Duchamp, was by Beatrice Wood, and was in part based on a conversation overheard between George Bellows and Walter Arensberg.

II, 6. Charles Demuth (1883-1935), an artist who exhibited at 291. His American landscapes, usually of industrial subjects, have Cubist elements but he is also known for works, unexhibited at the time, depicting the nascent New York gay scene, and a series of "poster-portraits" of his close friends (including Charles Duncan, below) which in retrospect seem close to Pop Art (in particular the one for William Carlos Williams, *I Saw the Figure 5 in Gold*, of 1928). Demuth, Duncan and Duchamp were drinking companions, devoted to exploring late-night establishments of such seediness that many of their friends considered them beyond the pale.

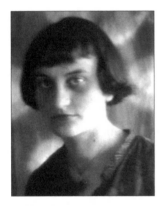

II, 7. Clara Tice (1888-1973) was an artist and illustrator who achieved considerable notoriety for her casually approving depictions, in various magazines of the period, of "the new woman", which was a role she also embodied in bohemian society. Her artistic career began, however, in *Rogue* and she was a prominent member of the fashionable set around this magazine, some of whom she portrayed (see p.16) in her signature drawing style. Her depiction of "Edgar Varèse composing" (whose surname she mis-spells as "Varais") is very different and is a rather obvious attempt to do modern art, the composer's head being formed from a musical note. It thus provides an interesting comparison with Beatrice Wood's *Marriage of a Friend* on p.157. Tice had close relationships with both Duchamp and Roché, who recorded in his diary spending the night with her in March 1917.

II, 7. Edgar Varèse (1883-1965) was one of the pioneers of modern music, and spent most of his life in the USA. Varèse came to New York at the end of 1915 after being invalided out of the French army, and his introduction into avant-garde circles followed his being hit by a car on Fifth Avenue. He ended up immobilised in hospital where various French-speakers were encouraged to visit him, among them

Duchamp and Wood. His liaison with Louise Norton dates from early 1918, at which point, according to Roché's diary, she foreswore "polygamy".

II, 7, S.T.E.K. The somewhat Picabian text/poem reads:

> Recharge, please, recharge
> with the chemistry of your saliva
> the battery of my heart.

II, 8. Walter Conrad Arensberg, see p.31 for biographical notes.

II, 8, "A Mother". Written by Wood "to show our liberalism", see p.166.

II, 9, Joseph Stella (1877-1946). An important American painter of Italian descent and a regular at the Arensbergs'. Stella was one of the directors of the Society of Independent Artists and was one of the few who were "in" on the *Fountain* affair, since he — along with Walter Arensberg, also a director — had accompanied Duchamp to the J.L. Mott Ironworks showroom at 118 Fifth Avenue to purchase a "Bedfordshire" urinal.

II, 10, Frank Crowninshield (1872-1947). The editor of *Vanity Fair* from 1914 to 1936, turning it to more literary ends than it was later to espouse, he was also an art critic for various New York reviews. An ardent supporter and collector of modernist painting, Crowninshield's support was particularly valuable at the time of the Armory Show and he became a close friend of Walter Pach, one of its organisers — hence the appearance of Duchamp in *Vanity Fair* soon after his disembarkation, photographed by Pach's father (p.6). In 1919, not long after the occurrence of the main events in *Victor*, Crowninshield founded a regular luncheon party that became famous around the world: the Algonquin Round Table.

II, 10. Francis Picabia, see p.28 for biographical notes.

II, 11, Louis Eilshemius (1864-1941). A professionally trained artist who studied under Bouguereau at the Académie Julian in Paris, and then travelled widely before

returning to New York where he lived for the rest of his life. His early works were landscapes after the Barbizon school which aroused little interest. In middle age, his works and behaviour became more unconventional and coincided with an outpouring of literature: novels, poems, philosophy… and acrimonious letters to the press. Suffering from a combination of paranoia and megalomania, he listed his professions on his business card as: "Amateur All Round Doctor, Mesmerist-Prophet and Mystic, Humorist Galore, Universal Supreme

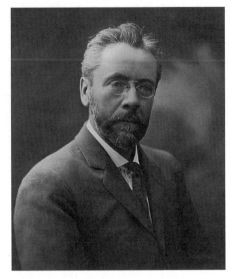

Critic, Spirit-Painter Supreme, Scientist Supreme: all ologies, Most wonderful and diverse painter of nude groups in the world", among many others, the list concluding: "All the supreme Genius Minds down the ages find Domain in EILSHEMIUS". Duchamp first encountered him at the Independents exhibition in 1917, and often thereafter expressed a genuine enthusiasm for his work. Duchamp also arranged an exhibition for Eilshemius at the Société Anonyme in 1920, but the hostility of the critics was so fierce that, once again rebuffed, he more or less gave up painting for good. He died in a psychopathic ward in Manhattan's Bellevue Hospital.

II, 11-12, Mina Loy (see pp.31-2 for biographical notes). She appears to be standing in for Duchamp here by writing this appreciation.

II, 12, Charles Duncan (1884 or 1887-1970). Coming from a modest working background, he combined the profession of sign painter with being an artist, but gave up the latter soon after appearing in *The Blind Man*. He was involved with Edith Clifford Williams, who is reputed to have invented "tactile art" with her *Plâtre à toucher chez De Zayas* (illustrated p.49); she too abandoned art in the early 1920s. In the circumstances, it seems not unlikely that Duncan was the sign painter Duchamp employed to paint the hand on his *Tu m'…* of 1918.

II, 13. Gabrielle Buffet, see pp.32-3 for biographical notes.

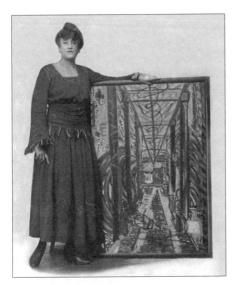

II, 13. Frances Simpson Stevens (1894-1976). An American painter who exhibited in the Armory Show, after which she moved to Florence and rented a studio with Mina Loy. She and Loy became fixtures in the local art scene and thus acquainted with the Futurists. Stevens was the only American to exhibit at the 1914 Esposizione Libera Futurista Internazionale in Rome (eight works). At the beginning of the war she returned to New York where she contributed cartoons to *Rogue* magazine. In 1919, she married Prince Dmitri Golitsyn and went to live with him in Siberia for two years; although they then returned to New York, nothing seems to be known of her after 1921.

II, 13, Allen Norton edited *Rogue* magazine with his wife Louise; together with Donald Evans they formed the Patagonians, championing free verse. His own poetry seems to have had heavy *fin-de-siècle* preoccupations, as evident in this brief effusion in *The Blind Man*.

II, 15, Stieglitz's letter. In response to Roché's invitation to comment on the Independents, Stieglitz proposed an anti-commercial strategy of withholding the names of the artists in future exhibitions. Stieglitz's resistance to commercialising the modern art in his gallery 291 had led to his protégé de Zayas opening the Modern Gallery on 7 October 1915. De Zayas had attacked Stieglitz in the very magazine he edited, *291* (no. 5/6, July/August 1915), for relying on "psychology and metaphysics" and failing to promote an "American" art, which, he argued, Picabia was now producing. Initially wary about Duchamp, Stieglitz recognised that they shared a similar spirit of play and they became friends.

BEATRICE WOOD

I Shock Myself
(Extracts)

Henri-Pierre Roché in June 1918.

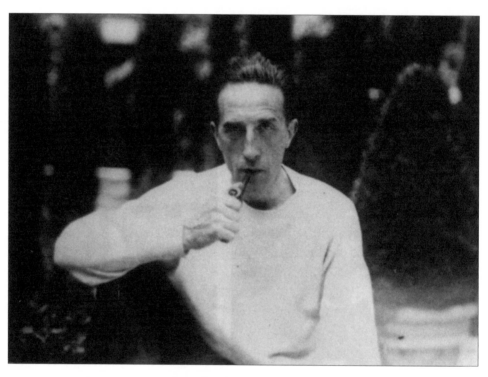

Marcel with his familiar pipe.

The photographs in this section (except the last one) were taken by Beatrice Wood and appear in her autobiography or in the extract from it published in Arts Magazine *in May 1977. The captions are her own.*

On my third visit to see Varèse my life was to change, for Marcel Duchamp was there. The most celebrated painter of his day, due to the sensational success of his *Nude Descending a Staircase*. Marcel at twenty-seven had the charm of an angel who spoke slang. He was frail, with a delicately chiseled face and penetrating blue eyes that saw all. When he smiled the heavens opened. But when his face was still it was as blank as a death mask. This curious emptiness puzzled many and gave the impression that he had been hurt in childhood.

Though I was delighted to know a man as masculine as Varèse, my attention changed the moment I met Marcel. Immediately he addressed me as *tu*, the French familiar of "you", used only with friends, family — or lovers!

When Marcel and Varèse launched into a discussion on modern art, I shrugged my shoulders and put in: "Anyone can do such scrawls."

Marcel replied wryly: "Try."

Back at home I sketched *Marriage of a Friend*, a tortured abstraction. Marcel liked it so much he published it in a small avant-

"Marriage of a Friend"

Marcel's studio.

garde magazine, *Rogue.* Edited by his good friend Allen Norton, *Rogue* was a revolutionary sheet in 1916. Gertrude Stein wrote a few lines for it.

"Why don't you paint?" Marcel asked me. "You can't always be so busy rehearsing'?"

Varèse frowned, as he always did when the conversation drifted off the subject of music.

"No room at home."

"Then come to my studio. Often I am away. Come once, twice a week. Phone first, so I can tell you if it's all right. I'll be frank with you. There may be times when I don't want you to come."

From then on, whenever I had a free afternoon, I phoned and asked whether the studio was free. He would usually tell me to come over: if not, I assumed a lady was with him. Marcel did very well in that department, although friends laughingly told me that Marcel's lady friends were usually quite homely. Marcel later commented that unattractive women made love better than beautiful ones. Sex and love, he explained, were two very different things. I did not know what he was talking about.

Marcel's square room looked out on to a narrow court, facing the back of the apartment. A double bed, usually unmade, filled one alcove. There were two chairs. Generally covered with clothes and canvases in disorder everywhere. On the windowsill lay boxes of crackers and packages of Swiss chocolate, his regular diet. The room gave the impression of being in various stages of undress.

After the crowded luxury of my parents' home, I found this chaotic space an oasis of peace. Marcel knew I was in love with his good friend Roché and did not approach me amorously. Secretly I wished he would. My love for Roché could not keep me from being a little in love with Marcel, for he was a must charming man, with a devastating smile. I found myself dreaming about him all the time.

If Marcel was out when I came, he would leave the key for me. If he was in his studio, he sat quietly in a chair with his legs crossed, smoking a pipe, and watched me passively as I worked.

Henri-Pierre Roché, New York, 1916.

Then, at the end of the afternoon he quickly surveyed my sketches, one by one: "Good... bad... bad... bad... good... bad." Through his eyes I began to discover that the obvious was not art. He instilled in me an appreciation for independence in my approach to the making of images. In the beginning I was puzzled by what he liked and disliked, for the drawings I considered good — realistic heads of women with curly hair — he disdained. He liked the ones that were free expressions of the unconscious. I had no idea what they meant. Sometimes, after a long afternoon of painting, he would take me out to dinner. Often we went to a Sixth Avenue dump but the elevated trains overhead sounded like music from the spheres, for I was with him. We were in harmony, whether in conversation or in silence. Except for the physical act, we were lovers.

Roché, who had known Marcel for years, thought it wonderful that I had

159

this opportunity to work with him and encouraged me to go to his studio as often as possible. He even teased me about being in love with Marcel. Instead of being jealous, he was delighted when I told him I dreamt of Marcel. For Roché loved Marcel too, as I think everyone who knew him did. Marcel was a beautiful, abstract, yet loving human being.

Henri, Marcel and I often dined together and both men would scold me about my lack of taste. They loved me in a paternal sort of way. Actually, they only wanted to cure me of my naïve idealism and bring me closer to reality. The two of them agreed about everything concerning me and conspired to see that my education took the course they approved. They were not interested in the theater; they wanted me to concentrate on art. The three of us were something like *un amour à trois*; it was a divine experience in friendship.

The Arensberg Circle

One night Marcel took me to meet two of his close friends, Walter and Louise Arensberg, who lived several floors below him on West 67th Street.

The Arensbergs were collectors — the first in America to respond to modern art. Their large two-story duplex had a sitting-room full of oriental rugs, carefully chosen early American furniture and comfortable sofas and chairs. But there on the walls — not only in the sitting-room but in the hall, the bedroom, bath, and kitchen — hung the most hideous collection of paintings I had ever seen.

Walking into this incredible home I caught my breath, suppressed a giggle, and sat down in a state of shock. One by one I confronted each disconcerting image as it shrieked out at me. The most awful, if I had to choose, was a Matisse, an outlandish woman with white streaks — like daggers — surrounding her entire body. Near the balcony was a Picasso filled with broken planes supposedly depicting a woman, and a Rousseau with a horrible dwarf in an unnatural landscape. Marcel's *Nude Descending*

a Staircase, a wild bedlam of exploding shingles, as it had been called, had the place of honor. With great pride they pointed it out to me. I mumbled that it "seemed to move," praying they would let me get by with that comment. Nearby on a pedestal was a Brancusi brass that shot up in the air out of nowhere and made me uncomfortable. Scattered throughout the room were works by Picabia, Gleizes, Braque, and Sheeler, African carvings and pieces from a mixture of periods. It made my head spin in disbelief.

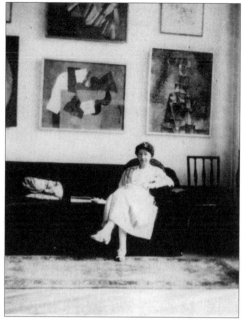

Louise Arensberg in the New York apartment, circa 1917.

Walter and Louise gave me such a warm and affectionate welcome that I felt at ease in spite of the paintings. The entire evening Marcel sat comfortably in a chair and observed my reactions. I had already told him that his readymades were beyond me. He would answer with one of his favorite expressions: *"Cela n'a pas d'importance,"* — it doesn't matter. Despite my absolute lack of true appreciation, the Arensbergs graciously insisted I come back often and, of course, I did.

Once again my life changed. At the Arensberg home I met poets, writers, painters, actors. Night after night they gathered around the grand piano and carried on fascinating and knowledgeable discussions on every imaginable subject. All of the artists of New York were found there sooner or later — Marcel, Roché, Albert Gleizes, Jean Crotti and his wife Yvonne Chastel, Man Ray, Francis Picabia and his wife Gabrielle Buffet, John Covert, Walter Pach, Joseph Stella, and Charles Sheeler... holding forth on freedom of expression in art. Louise — otherwise known as Lou — and I would

generally sit apart on the sofa, somewhat neglected by the others. She was not a beautiful woman; her nose was short and upturned, with lines on either side that ran down to her chin like streams trying to find a river. Her brown and curly hair was not flattering to her face. But she was direct and sincere and it gave her great charm. Walter, a poet from Harvard, was also charming, but he was not quite so sincere. His cordiality lit up for callers. Like royalty, he was always the gracious host. Men liked his intellect, while women responded to his warmth like moths to light. Lou watched in silence. She knew that he was somewhat unrealistic, and it was upon her simple strength that he truly relied.

Roché and I visited the Arensbergs once or twice a week; Marcel would join us later on in the evening. All the while they would toy with me, mischievously teaching me bawdy French slang without explaining the meaning, then suppress their glee when I innocently used one of the words in conversation. One Russian intellectual was so dismayed at my language he got down on his knees and begged me never to say such things again!

At midnight, Lou served drinks and hot chocolate, pastries and eclairs, and we would break up such inspired conversations. I often wondered what everyone was talking about, especially in the area of art. But I decided that since these beloved people thought the paintings had merit, and the artists whom they entertained spoke about them in hushed voices, the least I could do was try to enter their world of understanding. One night while Sheeler and Stella discussed color theory, I gazed at the terrifying Matisse over the fireplace. It was his *Portrait of Mademoiselle Yvonne Landsberg.* Willing myself to be open-minded, I almost went into a trance. My eyes locked on its angular lines, until suddenly out of the canvas appeared a creature of wondrous beauty; Matisse had spoken, and at last, I listened.

Meanwhile, Walter had become interested in the roles I was playing in the theater and spent hours coaching me. Many evenings we left the others and went into his study where I would practice my delivery. He loved the cadences of Shakespeare and with infinite patience corrected my intonations. We worked on Marlowe's *Hero and Leander* and Mallarmé's

L'Après-midi d'un faune, first in French, then in Walter's English translation. I was fascinated by the uncompromising time he gave to details. However, I was losing my interest in the theater. The stage with its lustful directors was growing unbearable. These exciting evenings with the Arensbergs were turning me away from the exhibitionism of the theater to the subtler esthetics of the other arts.

For the next two years I led a magical existence. The Arensbergs brought me the culture of the day; Marcel had revived my interest in painting, and Roché was teaching me the depths of a love relationship. To have such a life after my stifled youth was incredible! My only unhappiness was the war waging in my beloved France, for which my American associates had little interest. In those days there were no televisions or cross-Atlantic airplanes. Even at the Arensbergs' the war was never discussed; the only battles that occupied us were the ones against traditional values. The members of the Arensberg circle were not content to be merely a salon of impassioned intellectuals. One day, after months of complaining about the restrictions of formal jury-selected art exhibitions, they decided to hold an exhibition in which anyone could exhibit simply by sending in six dollars. At that time juries were the *bêtes noires* of the art world. The experiment, to be called the First Exhibition of the Society of Independent Artists, was to take place in the huge Grand Central Palace. (This, incidentally, is not to be confused with the Armory show several years earlier.) Publicity was circulated inviting artists to submit their work, which would be presented without the tyranny of formal selection. Walter and Marcel, Walter Pach and Picabia were the strongest forces behind the event: George Bellows, Walt Kuhn, Rockwell Kent, John Covert, Charles Sheeler and Stella all helped with the by-laws. The poetess Mina Loy, as well as Aileen Dresser, Arthur Cravan and De Zayas joined in the activity.

Two days before the Exhibition opened, there was a glistening white object in the storeroom getting readied to be put on the floor. I can remember Walter Arensberg and George Bellows standing in front of it, arguing. Bellows was facing Walter, his body on a menacing slant, his fists

doubled, striking at the air in anger. Out of curiosity, I approached.

"We cannot exhibit it," Bellows said hotly, taking out a handkerchief and wiping his forehead.

"We cannot refuse it, the entrance fee has been paid," gently answered Walter.

"It is indecent!" roared Bellows.

"That depends upon the point of view," added Walter, suppressing a grin.

"Someone must have sent it as a joke. It is signed R. Mutt; sounds fishy to me," grumbled Bellows with disgust. Walter approached the object in question and touched its glossy surface. Then with the dignity of a don addressing men at Harvard, he expounded: "A lovely form has been revealed, freed from its functional purpose, therefore a man clearly has made an aesthetic contribution."

The entry they were discussing was perched high on a wooden pedestal: a beautiful, white enamel oval form gleaming triumphantly on a black stand. It was a man's urinal, turned on its back.

Bellows stepped away, then returned in rage as if he were going to pull it down.

"We can't show it, that is all there is to it."

Walter lightly touched his arm, "This is what the whole exhibit is about; an opportunity to allow an artist to send in anything he chooses, for the artist to decide what is art, not someone else."

Bellows shook his arm away, protesting. "You mean to say, if a man sent in horse manure glued to a canvas that we would have to accept it!" "I'm afraid we would," said Walter, with a touch of undertaker's sadness. "If this is an artist's expression of beauty, we can do nothing but accept his choice." With diplomatic effort he pointed out, "If you can look at this entry objectively, you will see that it has striking, sweeping lines. This Mr. Mutt has taken an ordinary object, placed it so that its useful significance disappears, and thus has created a new approach to the subject."

"It is gross, offensive! There is such a thing as decency."

"Only in the eye of the beholder. You forget our by-laws."

["

There followed an article entitled "Buddha of the Bathroom" by Louise Norton (who was then married to the poet Allen Norton but who would become the wife of Edgar Varèse). There were also two poems by Walter Arensberg, as well as a letter from Frank Crowninshield, editor of *Vanity Fair*:

"Dear Blindman. You are, I hope, to be an instrument for the accomplishment of an important and much-needed work in America; namely, the fostering and encouragement of a truly native art."

Stieglitz also sent in a letter:

"As I understand the Independent Society its chief function is the desire to smash antiquated academic ideas. This first exhibition is a concrete move in that direction ... NO JURY ... NO PRIZES ... NO COMMERCIAL TRICKS."

There were also articles on Louis Michel Eilshemius, a primitive painter much championed by Marcel, poems by Demuth, Picabia, Mina Loy, Frances Stevens, and a picture of Edgar Varèse by Clara Tice. To show our liberalism, we decided to print another point of view, so I wrote a stuffy letter from a mother, making a plea to keep the exhibition sane and beautiful:

"It is only by elevating the soul and keeping the eyes of our young ones filled with lovely images that we can expect good results from the generation that will follow. Cubists, futurists, are not artists. For Art is noble, and they are distorted, the line must be drawn somewhere."

We were out to save the world. We were young…
One afternoon while Roché and Marcel were poring over the final proofs, they abruptly stopped when I arrived and motioned me to sit down. They had an urgent request: since they were both French citizens living in

America, they hesitated putting their names on *The Blind Man* as publishers. Therefore, could they use my name? Delighted, I consented.

Mailing lists were assembled and plans made for the magazine to be distributed on news-stands and in the subways. All would have gone well except for my father. Although not the tyrant my mother was, he was understandably protective, and his views traditional and conservative. At three in the afternoon, on the day *The Blind Man* was to be released, I went home and discovered huge stacks of magazines piled high in our apartment entrance. My father came out of the sitting-room to greet me. He had a strange expression on his face.

"It took two men to carry in these packages. I couldn't imagine what they were, so I opened one and saw they were magazines. I was astonished to find your name as publisher. You must be out of your mind. This is a filthy publication. I cannot believe a child of mine could be associated with such thoughts. I have never before interfered in your life, but I beg and plead with you to withdraw this from circulation." He continued sadly, without anger. "You are too young to understand the implications of what you are mixed up in. There are words in there no young girl should ever know. If it goes through the mail you will tangle with the law and be put in prison."

The idea of jail did not bother me; it would be another new and exciting experience. But my father was a good and decent man, even if he did not understand art, poets or painters. Moved by his despair, I raced down to see Frank Crowninshield at his office at *Vanity Fair*.

He received me with open arms, an amused grin on his face. He had pinched features and cheeks with little lines running all over his face like on a road map, but his eyes, small and alert, were dancing with enthusiasm.

Just the week before we had gone over the proofs together and found nothing unprintable. But when I told him how my father had reacted, and suggested that other men might feel the same, Frank saw my point. Mrs. Whitney had put up the money and many prominent names, including Frank's, were associated with it. We had never thought about the laws concerning decency. What if our artistic tract was deemed pornographic?

We dissolved into peals of laughter. "Your father must consider you the queen of anarchists," Frank chuckled. Although we still could not find the words my father objected to, Frank decided it would be best to bypass the mail and distribute *The Blind Man* by hand. This made our little issue a *succès du scandale*.

I ended up being involved in yet another scandal concerning the Grand Central Palace show. Marcel, with his whimsical humor, encouraged me to send two paintings to the exhibit. Of the many I had done at his studio, he chose a horrible composition called *Nuit Blanche*. Fifty years later, when it was hanging in the Philadelphia Museum, I had a speck of understanding into why Marcel chose it. After all, what is taste? There is no true standard; people exposed to certain idioms of expression develop a sensitivity to their own personal values. I liked blue skies and Maxwell Parrish, but Marcel responded to works free of school influences.

In addition to *Nuit Blanche*, Marcel suggested that I send in an oil painting, a fairly abstract nude torso of a woman in a bath-tub, shown from neck to knee with a piece of soap drawn at the "tactical" position. He studied the painting and said: "You must put a soap there, real soap, instead of painting it. Shop carefully and choose a piece that goes well in color and form with the composition."

He then helped me glue the scallop-shaped soap to the canvas, and when I mistakenly called the piece *Un peu d'eau dans du savon*, instead of *Un peu de savon dans l'eau*, he chose my slip of the tongue for its title — "a little water in soap."

To my astonishment, the painting, perhaps the first assemblage or abstraction by an American to be put on public view, attracted more attention than any other entry. Crowds stood in front of it chuckling, men left their calling cards, and the reviews gave it more space than that given to serious artists who truly deserved it. Marcel was delighted that his prankishness had come home to roost, and the harsh reviews pleased him all the more. To celebrate the exhibition, a ball was planned to be held in Greenwich Village, and Marcel wanted me to make a poster for the event.

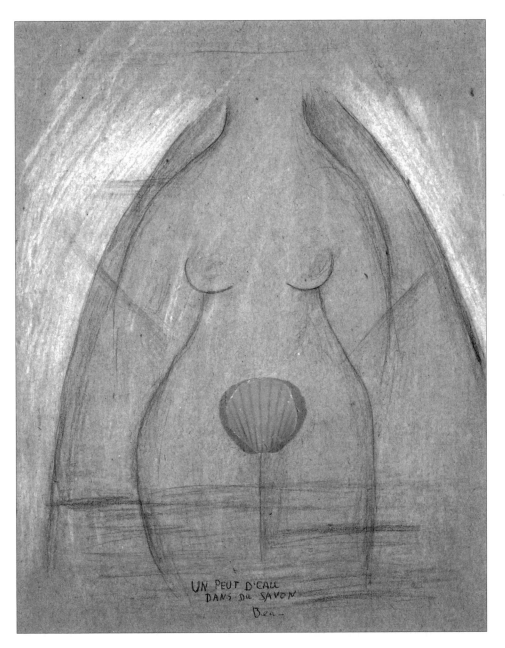

A Little Water in Soap, *1917, reconstructed 1977.*

This meant more happy hours in his studio. I sat on a stiff chair in the middle of the room and made sketch after sketch. When I was finished, he took them and threw them on the floor. To my astonishment, he chose an insolent stick figure thumbing its nose at the world, which I had tossed off. He took it to the printer, arranged for its size and color, and years later the poster became a highly treasured collector's item.

The Blindman's Ball was a riotous affair; the whole art world attended. Michio Itow, the famous Japanese dancer, gave an impressive performance and I repeated my Russian folk dance. Marcel climbed up on a chandelier while the Arensbergs, Roché and I applauded from a box. Joseph Stella had a duel over me, though I never found out why — something about protecting my honor, which no longer existed!

It was three in the morning when we gathered at the Arensbergs' apartment for scrambled eggs and wine. Since it was too late to go home, Mina Loy led several of us off to spend the night at Marcel's apartment. Sleepily, we threw ourselves on to his four-poster bed and closed our eyes like a collection of worn-out dolls. Mina took the bottom of the bed with Aileen Dresser against her, and Charles Demuth, the painter, lost no time in draping himself horizontally at right angles to the women, with one leg dangling to the floor, a trouser tugged up revealing a garter. Marcel, as host, took the least space and squeezed himself tight against the wall, while I tried to stretch out in the two inches left between him and the wall, an opportunity of discomfort that took me to heaven because I was so close to him. Lying practically on top of him, I could hear his beating heart, and feel the coolness of his chest. Divinely happy, I never closed my eyes to sleep.

When I returned home, Mother was standing like an Inquisitor at the door, ranting over my spending the night with Marcel. Her accusation went through me like a knife; she denounced me as if I were a harlot. All this for what she thought was my illicit night with a famous French artist. Imagine if she had known about Roché!

In tears she complained that she never saw me any more and had no idea how I spent my time. "I am twenty-two," I proclaimed. "You are always

questioning me! From now on I will no longer tell you where I go nor what I do!" I saw her hands tremble while her next words revealed the dungeon in which she wanted to keep me. "I would rather see you dead than have a lover," she said, and buried her face in her hands.

She loved me so much and believed I was a special, talented person who had to be protected. The last thing I wanted was her protection. Yet it was difficult for me to completely defy her for I truly loved her. I was born willful and had an intensely independent, almost wild, nature. She was ever the watchful hawk. We both suffered terribly, but perhaps my mother more, for she suffered the anguish only a mother can feel. She was a beautiful and generous woman, with great charm and style. Her friends loved her and thought me some kind of monster, which in a way I was. The real monster was the generation gap. Roché and I were forever talking together. Even when we left off, after hours of conversation, we could hardly wait to meet again.

Because I loved him so much, or perhaps because I was a woman, I wondered how many times he had been in love before he met me. I knew it was possible to love only once as we did. But he was forty years old. He had traveled and met many women. I decided since he was so old, he might have been in love twice before. Then, wanting to be generous and broadminded about his past, I concluded he might have been in love three times. I did not want to hear about it, yet I did... One day I found the courage to ask.

He was resting on the couch near me, his arm around my shoulder. "Roché... you must have been in love before."

"Of course."

"Was it often?" I hoped he would say no. "I don't remember."

"Oh, but you can't forget something like that."

"Chérie, a man doesn't think about how many times he's been in love." He kissed me.

"Please tell me," I snuggled up to him. "One does not forget when one sleeps with a person."

"It depends upon what you call love," he murmured, his arm tightening

around me. "It's not always love when a man and woman sleep together. I have loved many women. I have forgotten how many. Perhaps a hundred, perhaps more. I do not even remember their names or what they looked like."

"A hundred! But that is awful!" I drew away from him, breathing like a tigress.

"Falling in love isn't as easy as that."

He chuckled and drew me tight into his arms. "Men love easily. It is different with women. A man can sleep with a woman and never see her again."

"Oh, no!" I cried as my world shattered and my romantic dreams fell into pieces, never to be put back together. I could not conceive of being in the arms of a man without love.

He kissed me softly, his voice almost a whisper. "You see, had I met you earlier my ways would have been different. I would have loved you all my life. There would have been no other."

I felt faint. The world was not as I had imagined. I who had chosen not to be protected from reality where love was concerned, now wanted very much to be protected.

Several weeks passed. Roché had to make a trip to Boston and I missed him terribly. When he returned he was more loving than ever and we enjoyed being alone so much that we almost regretted the evenings spent with the Arensbergs.

One afternoon I went downtown shopping and found myself near his place. I phoned: he said I could come by for a short time but that he was working on a government paper. People in love are sensitive to each other. A few evenings later, it suddenly came over me that there was something different in the air.

"Roché?" I said.

A fly buzzed around the lamp. "Yes." He continued typing. The silence was wrong.

I watched him.

Then I suddenly heard myself say: "You have been unfaithful to me." He stopped typing and turned to me, sadness in his eyes.

"Yes."

"Oh…" I murmured.

"It was nothing. It did not mean a thing."

But I knew that it did. I saw the whole betrayal. "Alissa?" I whispered. My friend, Alissa.

"Yes."

He kissed my neck, my cheek, never had he been so tender. "Little one, believe me, it did not mean a thing. I do not love her. I was calling on her, talking about a book, the fire reflected on her white neck — and it happened."

Now I understood why she had been so eager for me to become friends with Varèse. Silently, he held me, while the refrain kept going through my head, "… the fire reflected on her white neck." For the whiteness of a neck, he threw away our relationship.

We both wept. At last I spoke, "I cannot understand… although I do understand… but it is so terrible for me that I cannot go on. This is the end between us."

His tears fell on my cheek, and mine on his. For an hour we remained in each other's arms, close as if we were one. I never suspected the world could be like this.

Finally I moved away from his embrace and, trembling inside, kissed him goodbye and walked out of his room.

With tears pouring down my face I took the subway and went home.

In shock, I endured the next several weeks in a state of despair. Had I been older, more mature, I might have accepted Roché's infidelity… I do not know… instead, I felt I had been betrayed.

My relationship with Marcel soon took a more personal turn, now that I was no longer sleeping with his friend. It was natural that we would become as close physically as we were emotionally. It was a comfortable relationship,



without agonizing ties or the tyranny of heartbreak.

One night he and Picabia took me to Coney Island. Because I feared roller coasters, they made me go on the most dangerous one over and over, until I could control my screams. They enjoyed themselves enormously. So did I, for with Marcel's arm around me, I would have gone on any ride into hell, with the same heroic abandon as Japanese lovers standing on the rim of volcanoes ready to take the suicide leap.

It was late at night when we returned from Coney Island. Walking ahead of both men, I noticed three sailors coming towards me. A policeman saw them divide as I passed through and was about to arrest me for soliciting, when Marcel came to my defense, while Picabia, who was Spanish, attacked the policeman with his fiery temper. To be mistaken for a prostitute crowned the dreamy evening, and we ended the night with roars of laughter. It was a respite from my depression and lingering unhappiness over Roché. Despite my love for Marcel, it was not the kind of romantic attachment that could cure a lover's heartache.

Marcel, Francis Picabia and me at Coney Island, 21 June 1917.

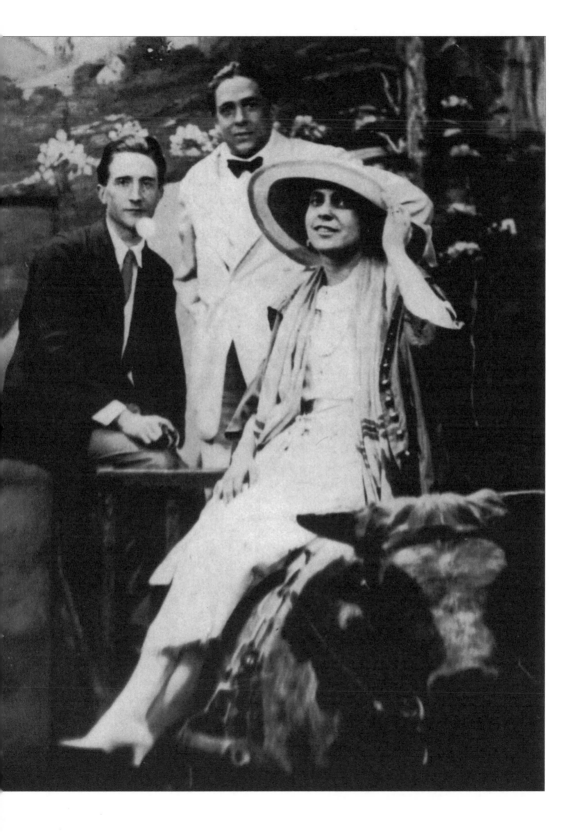

ACKNOWLEDGEMENTS
Our thanks for all their kind assistance to: Radha Sloss and Kevin Wallace at the Beatrice Wood Center, Happy Valley; Jacqueline Matisse Monnier and Paul Franklin at the Association Marcel Duchamp; Michael Taylor and Susan Anderson at the Philadelphia Museum of Modern Art; Elizabeth Garver at HRHRC at the University of Texas at Austin; and to Janat Dundas, Francis Naumann, Antony Melville, Roger Conover, Christian Briend, Dennis Duncan, Patricia Guenter and Ornella Volta.

PICTURE CREDITS
p.17 top, Harry Ransom Humanities Research Center at the University of Texas. 24, 27 right, 154, 175, Jean-Claude Roché. 29, 78 right, 120, 156, 157, 158, 159, 161, 169, Beatrice Wood Center for the Arts, Happy Valley Foundation, Ojai, California. 30 bottom, 31 top, 36, 61, 62 top and bottom, Philadelphia Museum of Art: The Louise and Walter Arensberg Collection, 1950. 31 bottom and 33 (Mina Loy and Arthur Cravan) courtesy of Roger Lloyd Conover. 55, Walter Pach papers, Archives of American Art, Smithsonian Institution. 74, 88, 91-2, Jean-Jacques Lebel archive, Paris. 150 top, the Rev. Lanny Wenthe Collection, Bridgton, Maine. All others private collections or public domain.

RELATED TITLES FROM ATLAS PRESS
Atlas Press publish numerous titles of related interest. For a complete list of all available titles, and to sign on to our emailing list for news of books as they are published, please see our website at www.atlaspress.co.uk.